United States of America by
ber of
Group
r

ts 01915-6101
9590

m
ypepad.com for a behind-the-scenes peek at our crafty world!

Cataloging-in-Publication Data

2 ideas for handmade, upcycled print tools / Traci Bunkers.

3-598-9
8-4
nting. I. Title.

2009039118
CIP

3-598-9
3-4

mdesign.com
la Rasa
ream / www.lightstreamns.com

China

Print &
Stamp La

First published in th
Quarry Books, a mer
Quayside Publishing
100 Cummings Cent
Suite 406-L
Beverly, Massachuse
Telephone: (978) 28:
Fax: (978) 283-2742
www.quarrybooks.c
Visit www.Craftside.

Library of Congres

Bunkers, Traci.
 Print & stamp lab :
 p. cm.
 ISBN-13: 978-1-59:
 ISBN-10: 1-59253-£
 1. Rubber stamp pr
 TT867.B96 2010
 761--dc22

ISBN-13: 978-1-592
ISBN-10: 1-59253-5

10 9 8 7 6 5 4 3 2 1

Cover Design: brad
Interior Layout: Tab
Photography: Light

Printed and bound

BEVERLY MASSACHUSETTS

QUARRY BOOKS

Print &
Stamp Lab

52 Ideas for Handmade, Upcycled Print Tools

Traci Bunkers

Contents

UNIT 1

Printing Blocks & Stamps 20

UNIT 2

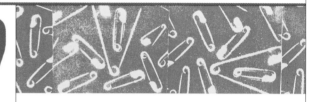

Moldable Foam Stamps 64

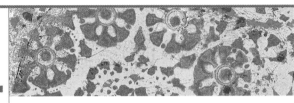

Introduction

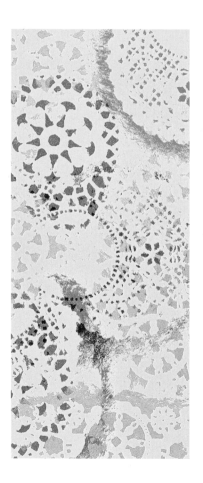

THE AIM OF THIS BOOK is to share my excitement for what I call alternative printmaking. People of all skill levels, from unschooled to seasoned artists, can easily create unique and interesting prints with normal (and abnormal) objects—no fancy or expensive equipment is needed! Whether you want to make a simple greeting card or an elaborate piece of art, this will open your eyes to a new world where everyone is welcome. And the printmaking fixin's are everywhere!

One of my super powers is that I can turn just about anything into an interesting stamp, printing block, or tool. (I'm the female version of MacGyver when it comes to art making and art-making tools.) I've had this skill since I was a kid, the product of a blue-collar family that was very practical, where making our own things was just what we did. Since we had limited resources, we figured out how to make do with what we had, or to use something else as a substitute. That's when my skill for looking at things with a fresh eye for repurposing and reusing started.

This skill helps me tread lightly on this earth while doing what I love, which is making art. I don't create much waste because I always use my leftovers for something else, whether it's collage material or a finished piece in itself. It also helps me to have an open mind and to work freely without worrying about or being tied to the outcome. For me, problem solving is a normal part of the art-making process, regardless of the media used. If something happens that I

don't like, a creative fix usually results in something better than if I hadn't taken that interesting detour. This openness and fearlessness makes it possible for me to keep the juices flowing with new ideas, not only in my artwork, but also with new printmaking tools.

So step into my world and I'll teach you how to see overlooked, everyday objects in a new way, and how to turn them into easy-to-use printing blocks and tools. Why be restricted to only using commercial rubber stamps when you can make your own stamping and printing tools? Use them to enhance your artwork, clothing, furnishings, and paper goods, or to create a new piece of art. The various methods I'll cover range from very simple stamping to creating printing blocks and stamps from inexpensive materials. If you already have experience in stamping and printmaking, this book will expand your arsenal. Regardless of where you are on your artistic path, you'll have fun making your own printing and stamping tools, and you'll never be able to pass another hardware store, thrift store, garage sale, or dollar store again.

Many of the tools and projects featured here are created from thrift store or dollar store finds, or things found lying around the house. It isn't necessary to spend a lot of money, and for this reason, experimentation is encouraged. Reusing items breathes new life into them and is good for the planet and the pocketbook! Besides, the "hunt" is part of the fun, whether it's for something to use as a printing tool or something to print on.

Overview

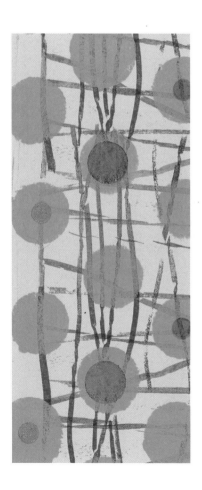

How to Use This Book

Print & Stamp Lab is made up of fifty-two labs organized into four different units. Each unit covers a different type of printing or stamping tool. The labs within the units progress from the easiest to make or use to the hardest, but it's not necessary to work an easier lab in order to gain a particular skill for a harder lab. Also, the complexity of the tool has no bearing on how interesting its print is. Different tools can be used alone or together to make an endless variety of designs and prints.

Work through the book in any order you choose. Working with a friend, on the same lab or a different one, can be fun and add to the experience. Not only can you compare the results, but you can also feed off of one another's energy and ideas. This can help you think of different combinations or materials that you might not have come up with on your own.

While making experimental prints, make notes either on the back of the print or in a separate book. Note which tools, paper, and paint or ink were used, along with any other helpful information, for example: "I got a crisper stencil design when the brush was dry without much paint on it."

While making tools and prints from the book, set aside enough time to experiment. Try not to control the outcome, and just have fun. If you enjoy the experience and don't worry about the final product, you'll have a much better time, and you'll end up with better results.

Each lab has the same format, listing Materials, Instructions, and Tips. Under **Materials** is the supply list for making the tool or stamp for that lab. **Instructions** are the basic steps for how to make the tool and how to use it to make a print. **Tips** give some variations of materials or other things to try based on that particular lab. Each lab shows the materials, the finished stamp or tool, and three different prints: a simple print, a slightly more elaborate print using the same tool, and a complex print combining that tool with one or more tools from other labs. This will spark ideas for different ways to combine the tools.

At the very end of the labs is a gallery. It shows different projects, applications, combinations, and variations of everything that has been explored in the labs. Along with the photos is basic information. More information on the material used for the projects can be found on my website: www.tracibunkers.com. The gallery is meant to be an inspirational jumping-off point to show how everything you have learned can be put together and used artistically on just about any surface imaginable. The sky is the limit!

Okay, go have fun making tools from fun and funky stuff!

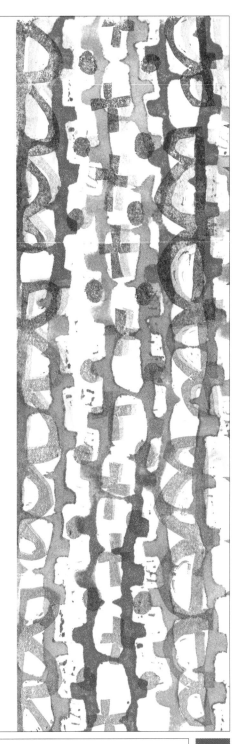

Basics

Some Basic (and Essential) Information Before You Get Started

The following is some general information that will be helpful as you create and use your various printing tools and stamps.

Base Material for Building Stamping and Printing Blocks

A base (or block) serves two purposes: it is a foundation on which to mount loose materials, and it makes a thin item easier to handle while printing. Just about anything sturdy can be used as a block. Wood is durable, but unless you have power tools or a handsaw to cut the wood to the size you want, or know someone who will do it for you, it's not the easiest thing to use. You can sometimes find wood blocks of different sizes in crafts stores that will work fine, and most hardware stores sell strips of wood and wood trim in different widths. Wood that's sold by the foot (0.3 m) can be cut into different widths for different sizes of printing blocks.

Luckily, I have my own power tools, and I know how to use them! But a quick and easy alternative to wood is foamcore. Foamcore, also known as foamboard, is polystyrene foam sandwiched between clay-coated papers. It's sturdy and comes in two thicknesses: ³⁄₁₆" (4.8 mm) and ½" (1.3 cm). I prefer to use the ½" (1.3 cm) thickness because it's easier to grip when printing or stamping. But the ³⁄₁₆" (4.8 mm) thickness works fine, and it's less expensive and easier to find. It's also what I use when I need to make a thin stamp easier to handle.

Another good material for blocks is rubber stamp mounting foam. This ½" (1.3 cm)-thick foam has adhesive on one side and is easy to cut with a craft knife. Normally used to mount rubber stamps, it is more durable than foamcore, but it's also more expensive.

Cutting Foamcore or Rubber Stamp Mounting Foam

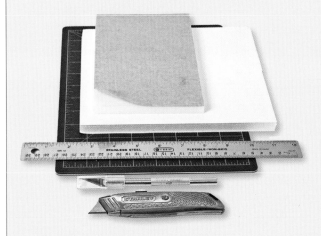

Always cut on top of a cutting mat so you won't accidentally cut the table. Also, always use a sharp blade to get a clean cut. A dull blade is harder to cut with and will tear the outer paper layers of the foamcore, leaving a ragged edge.

1. Using the ruler, measure the size of base you want to cut and mark it on the foamcore or the backing on rubber stamp mounting foam. Make the block the smallest size possible for what will be attached to it—ideally the same size. This makes it easier to position while printing.

2. With the cork facing down so the ruler won't slip, place the ruler along the marks and cut against the ruler using a sharp craft knife. Be sure to keep your fingers out of the way! Don't try to cut through the whole depth in one cut. Make several passes with the knife, holding it perpendicular to the board. If you don't hold it perpendicular, you'll get an angled cut. I usually make about three passes to cut all the way through the thicker foamcore and rubber stamp mounting foam.

TIP: If you can only find the thinner foamcore, you can attach several pieces together with white glue or double-stick tape to get the thickness you want. If using glue, put some weight, such as a book, on top of the glued piece to make sure it dries flat and is stuck together well.

MATERIALS
- cutting mat
- craft knife or utility knife
- sharp blade
- cork-backed steel ruler
- foamcore or rubber stamp mounting foam

Cleaning Printing Tools

I clean most of my handmade printing tools with baby wipes, so they don't get really wet. If you want to be able to wash your tools with water, you should use wood or rubber stamp mounting foam for the base. That said, I have washed some foamcore printing blocks under the faucet, but just to be safe, I dried them immediately with a hair dryer. Regardless of the material used for the base, 4" x 4" (10 cm x 10 cm) is about the largest block you should make. Anything larger is hard to handle and hard to print.

Adhesives

Some of the materials that I use to make my stamps and printing blocks come with an adhesive on one side. That makes them really easy to use. For the other materials, I use either permanent double-stick tape or double-stick foam mounting tape. Both hold up incredibly well over time and use, whether used on wood, foamcore, or plastic. There are, however, a few materials that won't stay attached to the tape while printing. Generally these are things that are fuzzy, made out of fiber, or not solid, such as the little girls' ponytail holders used in Lab 17. Attach these items with white glue or gel medium.

PERMANENT DOUBLE-STICK TAPE

Double-stick tape can be applied to any type of base, whether it's flat like foamcore or wood, or round like a dowel or brayer. Make sure the double-stick tape is permanent. If you use the repositionable type, the materials won't stay in place. Tear off strips of the tape and entirely cover one side of the base. Don't worry if the ends hang over; you can trim those when you're done. Apply the tape in rows with the edges touching or slightly overlapping to make sure the surface is entirely covered. You can also buy adhesive sheets that are similar to double-stick tape, but I prefer the tape because it's easier to handle and it's also cheaper.

DOUBLE-STICK FOAM MOUNTING TAPE

Foam mounting tape serves the same purpose as the cushion under mounted rubber stamps—it cushions the stamp for better contact with the paper, which creates a better print. It's also great to use with materials of different heights,

such as those used for the Buttons Block in Lab 10. In addition to creating a cushion, the foam helps level everything out. You can find foam mounting tape in craft stores, hardware stores, office supply stores, and even dollar stores. But all foam mounting tape isn't created equal. Some is really, really tacky and will stick to your fingers. But if you manage to apply it to the block and attach your materials, it's fine. Experiment with different brands to see what works best for you. Alternatives include rubber stamp double-stick cushion or sheets of sticky-back craft foam. Because sticky-back craft foam has adhesive on only one side, adhesive will need to be added to the other side. That can be done with double-stick tape, or use a Xyron machine, which applies adhesive to the back of anything you run through it.

Regardless of what kind of adhesive tape or cushion you are using, after you've applied the items to the printing base, more than likely there will be exposed adhesive areas that are sticky, especially around the edges. The tackiness goes away with use, but if you want to get rid of it right away, sprinkle talcum powder or cornstarch over the exposed areas, and then shake off the excess. *Voilà!* The exposed sticky areas are sticky no more.

GLUE

White craft glue or gel medium can be used in the few cases when double-stick tape and foam mounting tape won't work. Cover one side of the base with glue, and then place the items on top. Cover with a piece of wax paper and place a weight, such as a book, on top of the base while drying to ensure good contact. The wax paper protects the book from any excess glue.

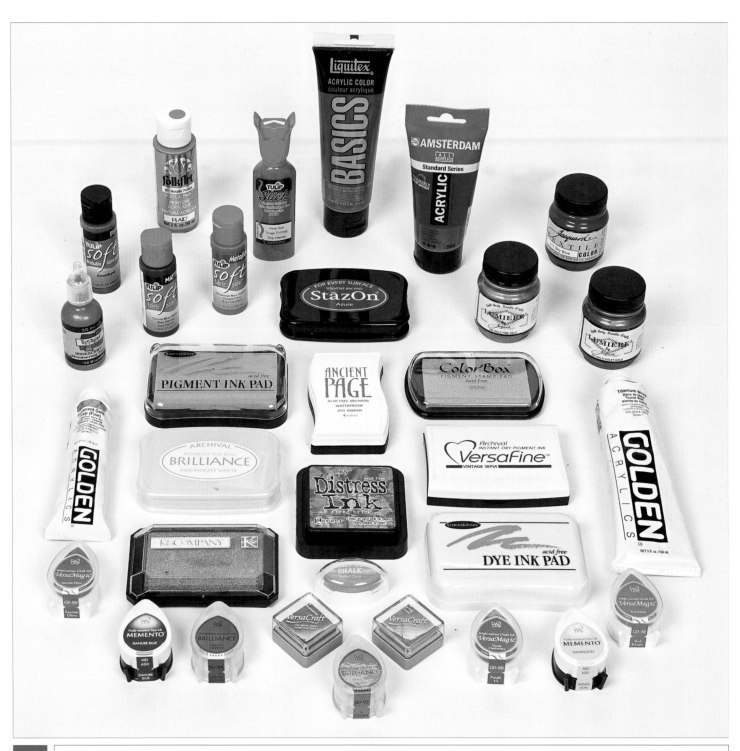

Paints and Rubber Stamp Pads

You may be wondering whether you should print using acrylic paint or rubber stamp pads. The answer is both! There are many variables, such as the tool you are using and what you are printing onto—some tools print better using paint, and some print better using a stamp pad. I've also found that the same type of tool prints differently for different people. Experiment to see what you like and what works best for you. A rule of thumb: If the stamp or tool is really detailed, like an intricate design on moldable foam, then a stamp pad will work best. Paint creates a "juicy" print, and some detail may be lost if it's applied too thickly or if the paint is too watery. Also, paint, if used with the moldable foam, even if washed well, tends to harden it, so the foam can't be remolded. (That's not always a problem because usually when I make a stamp from moldable foam, I think it's the greatest stamp I've ever made and I don't want to change it.)

When printing blocks or rollers have wire or things like paper clips on them, printing with paint works better. You can still print them with a stamp pad, but you'll get a lighter print.

There are inks made specifically for block printing (and you are welcome to use them if you like them), but they won't be covered in this book. Acrylic paints and stamp pads are easy to use, find, and clean up!

Prints from a flip flop showing the difference between printing with a stamp pad and paint. The top print used a stamp pad, and the bottom used acrylic paint.

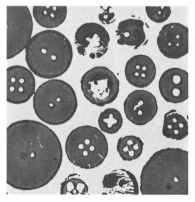

SOME THOUGHTS ON ACRYLIC PAINT

For printing, thick, heavy-bodied acrylic paints work best because they hold the design better. If a thin paint is used, it can run and not provide a crisp print. When using thick paint, you also have more paper options. Some papers bleed more than others when you print on them, and using thick paint alleviates this. But it's not always a problem. Sometimes you can get really interesting effects with slightly bleeding paint.

I have used a wide variety of acrylic paint—everything from Golden's Heavy Body Acrylics to the inexpensive craft paints that you get in hobby stores. They will all work fine, but with different results. As always, experiment and see what works best for you. The paper or surface you print on and the tool you are printing with will make a difference.

If you are printing on fabric or something that will need to be laundered, be sure to use fabric or textile paint. Acrylic paints can be used, but they have a tendency to leave the fabric stiff. If that's not a concern, then acrylic paints will work fine. Follow the manufacturer's instructions on fabric or textile paints; it might be necessary to set the paint before washing to make it permanent.

To print with acrylic paint, squeeze a small amount of paint, about the size of a quarter, onto a piece of Plexiglas. Roll a brayer back and forth over the paint until the paint is evenly distributed, then stamp onto paper on the Plexiglas. Press the printing tool into the layer of paint on the Plexiglas. If using a printing roller, roll it in the paint until the entire circumference is covered, then roll onto the paper.

Paint can also be applied to the surface of a printing block by rolling it on with a brayer. If paint dries on the Plexiglas, it can easily be scrubbed off so the Plexiglas can be used over and over again. Alternatives to Plexiglas are inexpensive picture frames with glass from a dollar store, or kids' plastic place mats. A foam plate can also be used, but be sure to wash it and use it multiple times before throwing it away.

The images above were all printed using paint.

SOME THOUGHTS ON ACRYLIC PAINT

For printing, thick, heavy-bodied acrylic paints work best because they hold the design better. If a thin paint is used, it can run and not provide a crisp print. When using thick paint, you also have more paper options. Some papers bleed more than others when you print on them, and using thick paint alleviates this. But it's not always a problem. Sometimes you can get really interesting effects with slightly bleeding paint.

I have used a wide variety of acrylic paint—everything from Golden's Heavy Body Acrylics to the inexpensive craft paints that you get in hobby stores. They will all work fine, but with different results. As always, experiment and see what works best for you. The paper or surface you print on and the tool you are printing with will make a difference.

If you are printing on fabric or something that will need to be laundered, be sure to use fabric or textile paint. Acrylic paints can be used, but they have a tendency to leave the fabric stiff. If that's not a concern, then acrylic paints will work fine. Follow the manufacturer's instructions on fabric or textile paints; it might be necessary to set the paint before washing to make it permanent.

To print with acrylic paint, squeeze a small amount of paint, about the size of a quarter, onto a piece of Plexiglas. Roll a brayer back and forth over the paint until the paint is evenly distributed, then stamp onto paper on the Plexiglas. Press the printing tool into the layer of paint on the Plexiglas. If using a printing roller, roll it in the paint until the entire circumference is covered, then roll onto the paper.

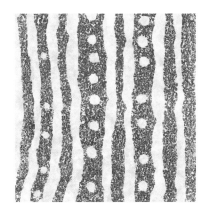

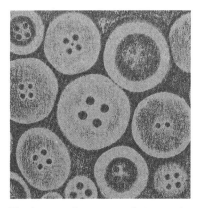

The images above were all stamped using stamp pads.

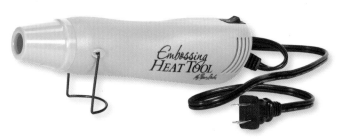

Carving tool

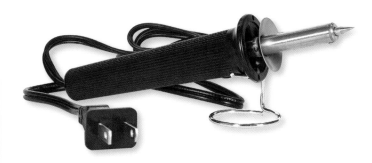

Embossing heat tool

Soldering iron

Equipment

Although most of the printing tools I use are simple to make, some require specific equipment. Scissors, a steel ruler, a cutting mat, and a craft knife are basic tools that most people are familiar with. Other small tools needed for some of the labs are carving tools (Labs 21, 40, and 41), an embossing heat tool (Labs 22–28 and Lab 35), and a woodburning tool or soldering iron (Labs 37–39 and Lab 52). All of these tools can be found in craft stores or art supply stores.

A carving tool is used to carve rubber stamps and linoleum. Only one handle is needed, and different types of blades, or cutters, are available to use with the handle. The smallest V cutter (#1) and a bigger V or U cutter are the only blades needed for the projects in this book.

An embossing heat tool is normally used to heat special embossing powders and to heat-set stamp pad ink. In unit 2, this tool is used to heat up foam to make moldable foam stamps. The heat changes the foam, allowing it to take on and hold the impression of any texture it is pressed against. An embossing heat tool is also used to melt foam pipe insulation in Lab 35. This tool does create a lot of heat, so keep it away from items that might be damaged.

In Labs 37–39, we use the heated tip of a soldering iron or woodburning tool to melt a design into foam, and it's used in Lab 52 to cut a stencil. Although soldering irons have only one tip, woodburning tools have different tips that can be used. For incising foam, use the smallest tip available. Some woodburning tools come with a specific tip for stencil cutting. You may also use the smallest tip for cutting stencils. Use care when handling these hot tools.

Cleaning the Printing Tools

Use common sense when it comes to cleaning your tools. The method used to clean them will depend on the base of the tool, whether it's waterproof like wood or rubber stamp mounting foam, and also how fragile it is. Some tools can simply be washed with soap and water. Others that won't hold up to that or don't need too much cleaning can be cleaned with baby wipes. I prefer the alcohol-free kind because they are gentler on the tools and also on your hands. Whenever I use stamp pads for printing, I clean my tools with baby wipes. I only wash them with water when using acrylic paint, and then only if they are too messy to clean with baby wipes. The same applies to cleaning my brayer.

Important Printing Tips

Here are a few printing pointers that will be helpful to you while you are working.

- Cover your work area with scrap paper, plastic, or wax paper to keep from getting paint or ink on the table and to make cleanup easier.
- Some printing blocks and rollers will print better if there is a cushion under the paper you are printing on. Use a sheet of craft foam, which can be found in the kid's section of craft or hobby stores, as a printing cushion.
- If a tool doesn't print well with one type of a stamp pad, try another kind. Different stamp pads use different types of pads to hold the ink, and some are firmer than others. If you have trouble, try a stamp pad that is spongier.

Printing Blocks & Stamps

WORKING ON THIS UNIT WAS VERY INSPIRING. I couldn't go into a store without seeing some new inexpensive item that I could turn into a great printing tool. Because of that, this unit is the largest in the book and uses a wide diversity of items. You'll stamp with items such as an earplug and a toe spacer (normally used for pedicures) and carve stamps from novelty erasers.

Some of the items can be used for stamping as is, without being mounted—I'll bet you'd never have thought to use them this way. Other items are mounted onto bases randomly or in a pattern to create a printing block.

A large number of the materials shown here can be found around the house or purchased inexpensively. Searching for odd items to repurpose into print-making tools is part of the fun. I love discovering a new use for everyday items that are taken for granted, such as paper clips or rubber bands. Printing with

UNIT 1

Tips

- With tools that list paint or stamp pads in the materials section, both work equally well for printing. Stamp pads show more detail but provide a lighter print.

- When using paint with flat printing blocks, apply it by rolling it on with a brayer, or by pressing the block into a layer of paint rolled onto Plexiglas.

- If the print is too light, especially when using a stamp pad, place a sheet of craft foam under the paper to act as a printing cushion.

ordinary things is much more exciting for me than using them as they were intended. Although specific items are used in each lab, they are meant to serve as starting points. Hopefully, they will inspire new ideas for printing experiments.

Most of these labs can be printed with either paint or stamp pads, achieving different results. Before you begin experimenting, read *Basics* on page 10. This has important information on base materials and how to cut them, acrylic paints, stamp pads, and printing.

Prints showing the difference between printing with a stamp pad and paint. The left print used a stamp pad, and the right used acrylic paint.

LAB 1 Earplugs & Corks

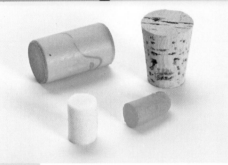

Materials

- earplugs or corks
- stamp pad or paint
- brayer and Plexiglas if paint is used
- paper

BECAUSE EARPLUGS ARE MALLEABLE, they print imperfect circles with every wrinkle showing. They also pop right back into shape. I've tried various kinds, and most give similar results. However, the latex-free earplugs print more texture than the latex ones do with stamp pads. They are also firmer and hold their shape better.

Carved corks have been used as printing tools for a long time, but I also like the textured print that they create just using them as is. Synthetic and natural cork print differently, and the mark left from a corkscrew entering and then being removed from the cork results in an appealing "grunge" look. Save the corks from your wine bottles or buy them from hardware stores. They come in various shapes and sizes.

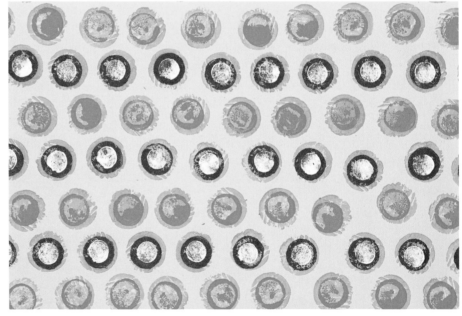

Stamped using paint on construction paper.

Instructions

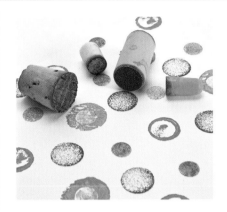

Press the earplugs or corks on the stamp pad or into a layer of paint rolled onto the Plexiglas and stamp onto the paper.

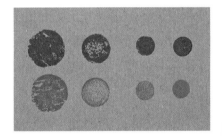

From biggest to smallest, stamped using natural cork, synthetic cork, latex-free earplug, and latex earplug. Blue was stamped with paint, and red was stamped with a stamp pad.

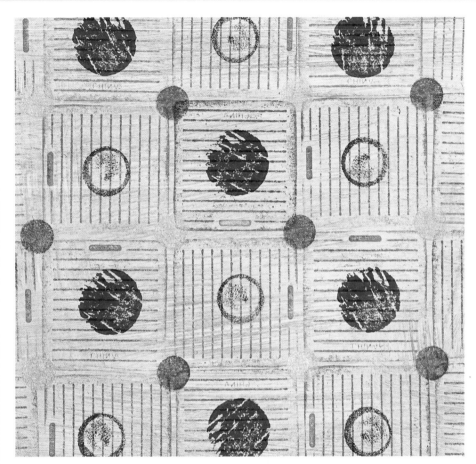

Cardstock was lightly covered with gesso, stamped using a furniture leg cup (Lab 5) with a green stamp pad, and then stamped with corks and earplugs using paint and stamp pads.

Tip

If you purchase a cork for printing, choose one with ends that are different sizes. That way you can print two different sizes of circles with one cork.

Bottle Caps

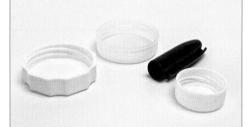

BECAUSE I LOVE PRINTING CIRCLES and I'm an avid recycler, using plastic bottle caps as printing tools is perfect for me. Look around the house for caps to suit your circle printing desires. You'll get the excitement of finding a new use for something that's normally thrown away and soon have an endless supply of circle-printing tools. Use both sides of the cap to print both outlined and solid circles.

- plastic bottle caps
- stamp pad or paint
- brayer and Plexiglas if paint is used
- paper

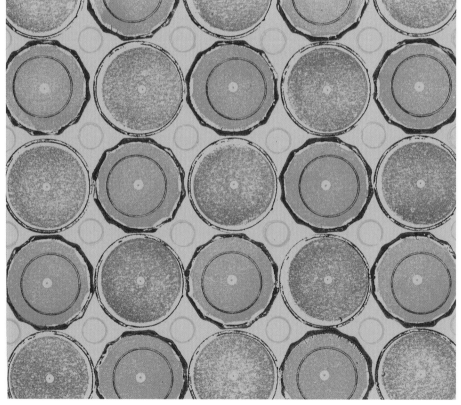

Stamped on cardstock. The blue and yellow are paint, and the rest used stamp pads.

Instructions

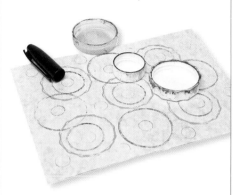

Press either side of the bottle cap on the stamp pad or into a layer of paint rolled onto the Plexiglas and stamp onto the paper.

*Printed on cardstock first with a wire wrapped dowel (**Lab 34**) using magenta paint, stamped with both sides of caps using paint and stamp pads, then stamped with a pencil eraser (**Lab 4**) using an orange stamp pad.*

The smallest circle is made with a marker cap and the rest are from drink bottles. Red was stamped with paint, and black was stamped with a stamp pad.

Tip

Look for different shaped caps to print a variety of circles. The largest cap with the straight edges on the outside came from a cranberry juice bottle.

LAB **3** Pencil Grips

Materials

- pencil grips
- stamp pad or paint
- brayer and Plexiglas if paint is used
- paper

IN THE SCHOOL SUPPLY SECTION OF STORES, you can find novelty pencil grips that are geared toward kids. They come in interesting shapes, sizes, and textures, making them great to stamp with and easy to use. Some of them can be stamped vertically, as if on a pencil, and also on the side. Plain old foam pencil grips also print very nice circles. Since pencil grips are cushiony and soft, they can be squeezed to print different shapes. And these are not just one-trick ponies. Use them for roller printing in **Lab 30**.

Stamped on cardstock in vertical columns. The red is paint, and the rest are from stamp pads.

Instructions

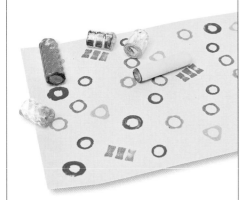

Press an end or side of the pencil grip on the stamp pad or into a layer of paint rolled onto the Plexiglas and stamp onto the paper.

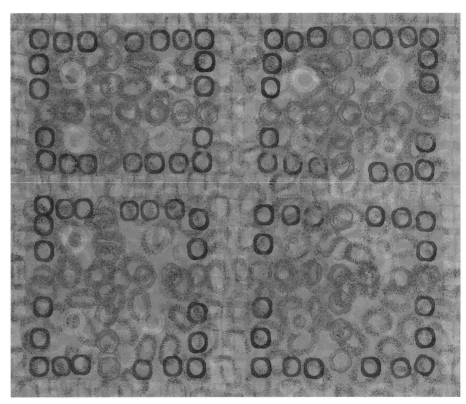

Printed on cardstock first using the ponytail holders block (Lab 17) layering with different colors of paint, then stamped with green paint and different colors of stamp pads using pencil grips.

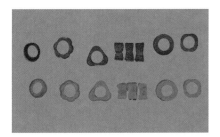

Prints from five different pencil grips. The print with the three bars is printed from the side of the triangular grip. Green was stamped with paint, and black was stamped with a stamp pad.

Tips

- To help hold the shape of the grip, put a pencil partially through it, so that the hole will still print.
- If the grip is too long, cut it shorter with scissors or a craft knife.

Pencil Eraser & Eraser Cap

A QUICK AND EASY WAY TO STAMP A CIRCLE is to use the eraser from the end of a pencil. The shape of the circle can vary depending on whether or not the eraser has ever been used for its intended purpose. Then there's the arrowhead-shaped eraser cap, a great multipurpose stamping tool. With just one simple eraser cap you can stamp an outlined circle, a dash, a rectangle, and a thin triangle! Use the two erasers together so you have both a solid circle and an outlined one.

- pencil with eraser or pencil eraser cap
- stamp pad or paint
- brayer and Plexiglas if paint is used
- paper

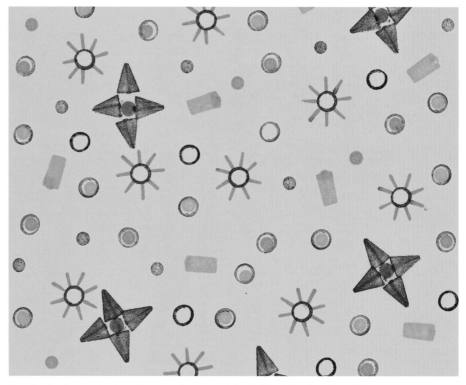

Randomly stamped using stamp pads on cardstock. The triangle sides of the eraser cap were pushed down, printing both triangles to form a larger triangle.

Instructions

Press the pencil eraser or part of the eraser cap on the stamp pad or into a layer of paint rolled onto the Plexiglas and stamp onto the paper.

Stamped using a stamp pad. The solid circle is from the pencil eraser and the rest are from the eraser cap.

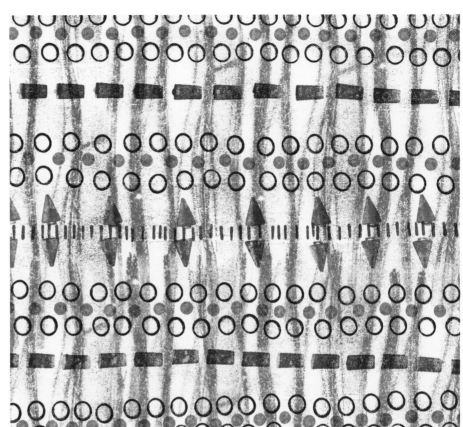

Printed on cardstock with stamp pads first using the pipe insulation roller (Lab 35), and then stamped using the pencil eraser and eraser cap.

Tip

Squeeze the open end of the eraser cap when printing to create circles that aren't perfectly round.

LAB 5 Furniture Leg Tips & Cups

- round furniture leg tips or square furniture leg cups
- stamp pad or paint
- brayer and Plexiglas if paint is used
- paper

NORMALLY, FURNITURE LEG TIPS AND CUPS are used to protect the floors from scooting chairs and furniture. They come in all different sizes of squares and circles and can be found in hardware stores. And you can print with both sides. The square ones, called "furniture cups," can print an outlined square on one side, and a square filled with gripper lines on the other. The round ones for chair legs, called "furniture tips," can print two different sizes of circles. When I first saw them, I went right for the biggest sizes. With printing tools, bigger isn't usually better, but in this case it sure was.

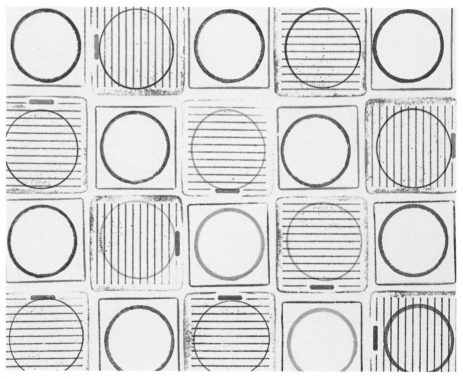

Stamped using a stamp pad, printing with both sides of the tools, on cardstock.

Instructions

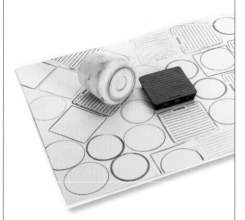

Press the furniture leg tips or cups on the stamp pad or into a layer of paint rolled onto the Plexiglas and stamp onto the paper.

Stamped using stamp pads on cardstock that was first brayed with orange paint (Lab 29) then printed with green paint using a paint trim roller (Lab 31).

Stamped using a stamp pad, printing with both sides of the tools.

Tip

Squeeze furniture leg tips when printing to create circles that aren't perfectly round.

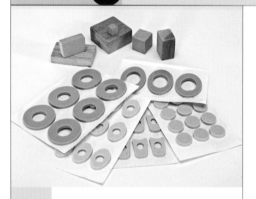

I'VE BEEN USING THE BASIC OVAL-SHAPED CORN CUSHION as a printing tool for years, and was happy to discover they came in different shapes and sizes. The best thing about them is they are cheap and have adhesive on one side, making it easy to attach to a base for printing. Since they are packaged with multiple pieces, you can make single printing blocks, or create a design with several on the same block. The generic kind work just as well as the name brand ones. The small, solid circle that is used here is the equivalent of a donut hole. It came from the center of the round corn cushion.

Materials

- materials for bases, see page 10
- corn or bunion cushions
- stamp pad or paint
- brayer and Plexiglas if paint is used
- paper

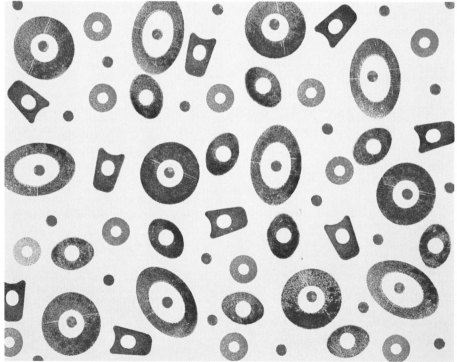

Stamped using a stamp pad on cardstock.

Instructions

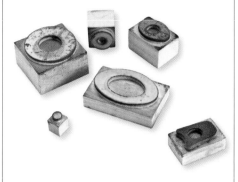

1. Cut the bases to the desired sizes.
2. Remove the corn or bunion cushion from the backing sheet, position on the base, and press down firmly to attach.
3. Press the corn or bunion cushion on the stamp pad or into a layer of paint rolled onto the Plexiglas and stamp onto the paper.

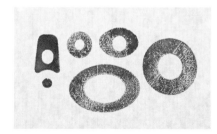

Stamped using a stamp pad.

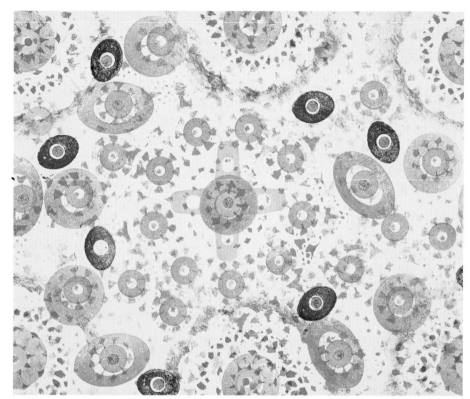

*Stamped using stamp pads on construction paper that was first stenciled with doilies (**Lab 44**) using different colors of paint.*

Tips

- Cut cushions in half to create arch shapes.
- Mount several onto one base for a larger stamp. Play around with them to find an interesting repeated pattern.

Toe Spacer foam

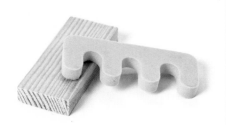

- materials for base, see page 10
- double-stick tape
- scissors or craft knife
- toe spacer foam
- stamp pad or paint
- brayer and Plexiglas if paint is used
- paper

ALTHOUGH TOE SPACER FOAM CAN BE FOUND in the beauty section of many stores or beauty supply shops, I first spied it in my local dollar store in a pedicure kit. My first thought was what a great stamping tool it would be. They come two to a package and in different shapes and sizes, so look around to see what interesting ones you can find.

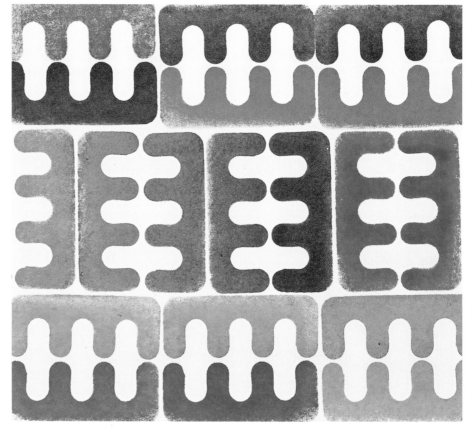

Stamped using stamp pads on construction paper.

Instructions

1. Cut the base the same width and length of the toe spacer foam, or to the desired size.
2. Cover one side of the base with double-stick tape and trim the tape.
3. Position the toe spacer foam on the adhesive-covered base, and press down firmly to attach.
4. Press the toe spacer foam stamp on the stamp pad or into a layer of paint rolled onto the Plexiglas and stamp onto the paper.

Stamped using a stamp pad.

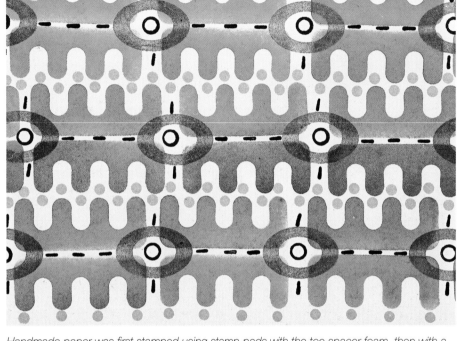

Handmade paper was first stamped using stamp pads with the toe spacer foam, then with a bunion cushion (Lab 6) and pencil eraser and eraser cap (Lab 4).

Tips

- This foam can be used without mounting it to a base. But because it's thin, it's easier to use when mounted.
- If mounting onto rubber stamp mounting foam, double-stick tape isn't needed.
- Because this comes with two in a package, both can be mounted onto one base for a larger stamp. Play around with them to find an interesting repeated pattern.

8 Foam Bit Caddy

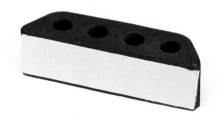

WHEN I SAW THIS FOAM DRIVER BIT CADDY in my local hardware store, I wasn't sure what it was for, but I thought this little piece of shaped foam with holes in it would make an incredibly cool stamp. I could already visualize the designs I could make stamping with its various sides. Its real purpose is to hold driver bits for drills, and the adhesive side is to attach it to the drill for safekeeping. I ran home from the hardware store with it that day and stamped like crazy, making all kinds of fun printed patterns (with holes in them).

- foam bit caddy
- stamp pad or paint
- brayer and Plexiglas if paint is used
- paper

Stamped using stamp pads on cardstock.

Instructions

Press the foam bit caddy on the stamp pad or into a layer of paint rolled onto the Plexiglas and stamp onto the paper.

Printed on cardstock that was first lightly covered with gesso, and then stamped with stamp pads using the rubber band block (Lab 12), a pencil eraser (Lab 4), and the foam bit caddy.

Stamped using a stamp pad.

Tips

- If you want to remove the adhesive backing but don't want the stickiness, paint a thin layer of paint over the adhesive and let it dry, or sprinkle it with talcum powder.
- Use the side of the foam bit caddy to print a solid rectangle.
- Attach several foam bit caddies to a base using double-stick tape to create a larger stamp. This will make an easily repeatable pattern.

Paper Clips Block

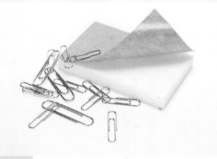

- materials for base, see page 10

- double-stick tape and scissors or craft knife (if using a base other than rubber stamp mounting foam)

- paper clips

- stamp pad or paint

- brayer and Plexiglas if paint is used

- paper

- sheet of craft foam for printing cushion

PAPER CLIPS ARE ONE OF THE MANY EVERYDAY THINGS that make interesting printing materials. They are inexpensive, come in all different shapes and sizes, and are easy to find. It's nice to use a variety of sizes on a paper clips block, but it's important that they all use about the same gauge of wire. If some are thicker than others, the thin ones won't print because they won't make contact with the paper. Any kind of base will work, but consider something that will hold up over time and take a lot of pressure. Here, rubber stamp mounting foam is used for the base because it's adhesive and a little cushiony. But because paper clips are so cheap, you can always just make another block if one with a foamcore base wears out.

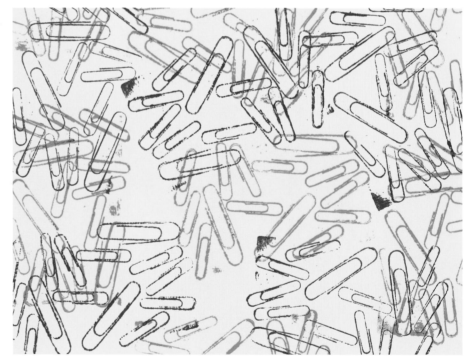

Randomly printed on cardstock with two different colors of paint.

Instructions

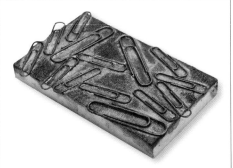

1. Cut the base to the desired size.

2. If using a base that isn't adhesive, cover one side of the base with double-stick tape and trim.

3. Randomly place paper clips of the same thickness on the adhesive, and press down firmly to attach.

4. Press the paper clips block on the stamp pad or into a layer of paint rolled onto the Plexiglas.

5. With craft foam under the paper to act as a printing cushion, press the paper clips block onto the paper, applying pressure, then remove it while holding the paper down.

Randomly printed with different colors of paint on cardstock that was first stamped with a brown stamp pad using the foam cube stamp molded with paper clips (Lab 28).

Red was stamped with paint, green was stamped using a stamp pad.

Tip

I don't recommend using foam mounting tape or double-stick cushion for this block. Because the paper clips are so thin, the cushion will print when the block is pressed down. Rubber stamp mounting foam is firm enough that this won't happen.

Buttons Block

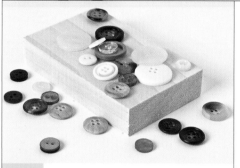

- materials for base, see page 10
- foam mounting tape (or adhesive cushion)
- scissors or craft knife
- buttons
- brayer
- thick acrylic paint
- Plexiglas
- sheet of craft foam for printing cushion
- paper

THE BUTTONS BLOCK IS ONE OF MY FAVORITE printing tools, and I love that it prints with a grungy look. Use buttons as close to the same thickness as possible. Even though the foam tape will act as a cushion to even out slight differences in the thickness, the thinner ones will not print if the difference is substantial. I prefer a wood base for this block because I use it so much, and the wood allows me to use a lot of pressure to be sure all of the buttons print. But, I've also used foamcore as a base, and it works fine, too. You can find grab bags or mixed tubes of buttons at craft, fabric, or even thrift stores.

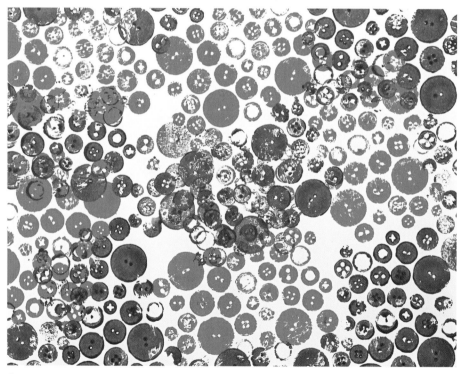

Stamped using paint on watercolor paper.

Instructions

1. Cut the base to the desired size.

2. Cover one side of the base with foam mounting tape or adhesive cushion, trim, and remove the adhesive backing.

3. Randomly place buttons of the same thickness on the adhesive, and press down firmly to attach.

4. Charge the brayer with paint, then roll it onto the buttons block, or press the block into a layer of paint rolled onto the Plexiglas.

5. With craft foam under the paper to act as a printing cushion, press the buttons block onto the paper, applying pressure, then remove it while holding the paper down.

Stamped using paint.

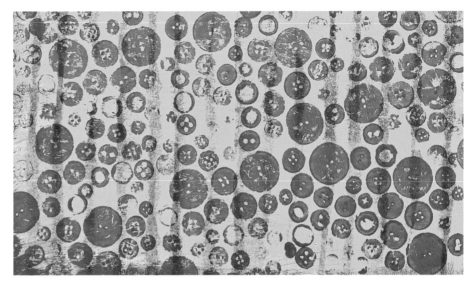

Cardstock was first lightly covered with gesso, brayed with yellow paint (Lab 29), then printed with green lines using a melted foam pipe insulation roller (Lab 35), and then stamped using paint with the buttons block.

Tips

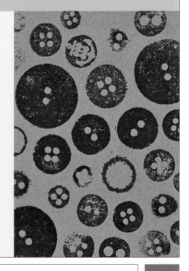

- Only the highest points of the buttons will print. Buttons with a raised brim that are placed facing up will only print as outlined circles. Flip them over to print a solid circle with holes. I like to combine a variety of sizes facing both ways.

- The buttons block prints best with thick paint, but can also be printed using a stamp pad (shown at right) if it is sprayed with a thin coat of workable fixative. The fixative gives the buttons something for the ink to hold on to. After printing with paint several times, the surface won't need fixative when printing with a stamp pad.

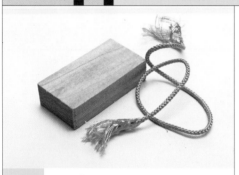

Materials

- materials for base, see page 10

- adhesive

- scissors or craft knife if double-stick tape or foam mounting tape is used

- cord

- stamp pad or paint

- brayer and Plexiglas if paint is used

- paper

WHILE IN ART CLASS AS A CHILD, while wearing my mom's old bowling shirt backwards for a painting smock, I glued yarn to cardboard and made messy prints. This is a slightly more sophisticated version of that block. Any kind of cord will work, but one that looks braided will add texture to the print. Depending on the kind of cord you use and how absorbent it is, you can attach it with either double-stick tape or foam tape, or you might need to use glue. Here, I used foam mounting tape, and it held up until I cleaned it too much with baby wipes. The cord soaked up too much liquid and started coming off after a while. So I dried it, added a little glue, and was good to go. I've used other cord and double-stick tape without any problems. Experiment to see what works best for you.

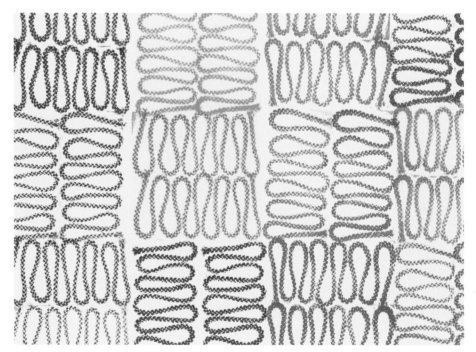

Stamped in alternating directions using stamp pads on cardstock.

Instructions

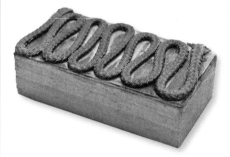

1. Cut the base to the desired size.

2. Cover one side of the base with double-stick tape, foam mounting tape, or glue, and then trim if neccessary.

3. Place the cord on the base in the desired pattern, and press down firmly to attach. (If glue was used as the adhesive, allow it to dry.)

4. Press the cord block on the stamp pad or into a layer of paint rolled onto the Plexiglas and stamp onto the paper.

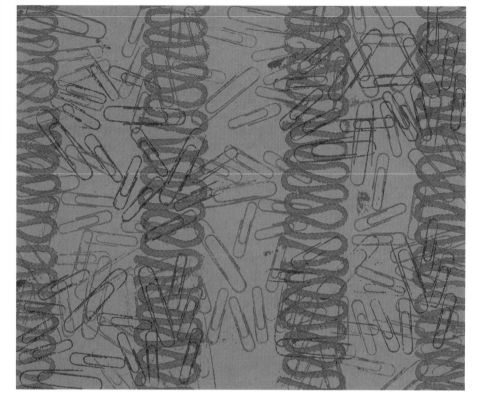

Cardstock was first printed with red and blue paint using the paper clips block (Lab 9), then printed with green paint using the cord block.

Green was stamped with paint, red was stamped using a stamp pad.

Tips

- If using synthetic cord, keep the ends from fraying by melting them with a lit match or a cigarette lighter. Clear fingernail polish can also be applied.

- Cord is also used to make a cord wrapped dowel in the roller printing unit (Lab 33).

Rubber Band Wrapped Block

RUBBER BANDS ARE PROOF that complicated or expensive items aren't needed to create graphically interesting images. They make a quick and simple printing tool that even a kid can put together. If you don't like the results, simply move the rubber bands around, add more, or remove some. This is instant gratification at its finest. Now you've got something to do with all of those rubber bands you've been saving, including the ones from the broccoli!

Materials

- materials for base, see page 10
- rubber bands in various thicknesses
- stamp pad or paint
- brayer and Plexiglas if paint is used
- paper

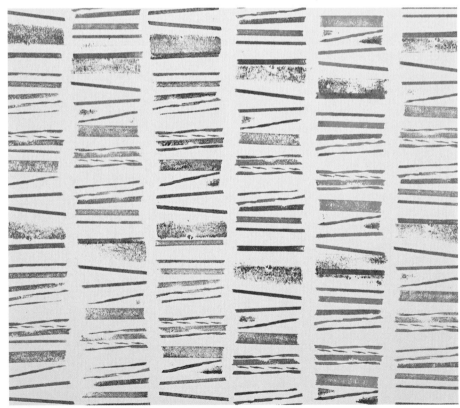

Stamped using stamp pads on construction paper.

Instructions

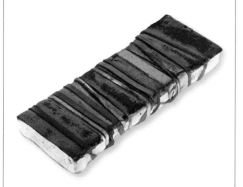

1. Cut the base to the desired size.

2. Wrap rubber bands of different widths around the base, making crisscross patterns, horizontal bands, or angled lines as desired. They can lay flat or be twisted, but try to keep the side that will print somewhat flat.

3. Press the rubber band block on the stamp pad or into a layer of paint rolled onto the Plexiglas and stamp onto the paper.

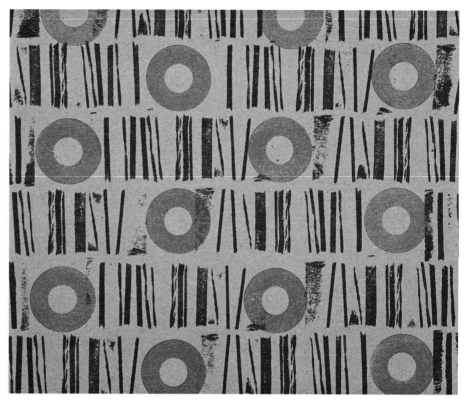

Stamped using stamp pads on kraft paper cardstock combined with a large bunion cushion (Lab 6).

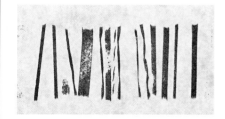

Stamped using a stamp pad.

Tips

- Try different shapes of square and rectangle bases, wrapping the rubber bands in different directions for more interesting patterns.
- Instead of cutting a base out of wood or foam core, look around for found objects that would make interesting bases.

YOU CAN GET NICE GRASSY-LOOKING LINES printing with wire, and just about any kind of wire will work. I like to use floral wire because it is cheap, thin, and easy to bend. As you wrap it around the block from the paddle that it comes on, it naturally makes little waves. It's impossible to keep the wire straight. Consider that an advantage. It creates a texture without having to do any fancy handiwork. The resulting image makes a nice background texture, but it is just as strong in the forefront.

Materials

- materials for base, see page 10
- craft knife
- floral wire
- wire cutters (scissors will work if wire isn't too heavy)
- stamp pad or paint
- brayer and Plexiglas if paint is used
- sheet of craft foam for printing cushion
- paper

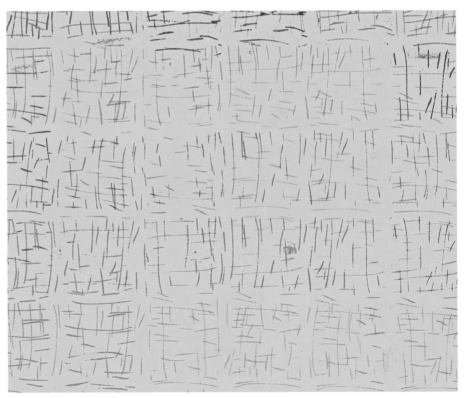

Stamped both horizontally and vertically using stamp pads on cardstock.

Instructions

1. Cut the base to the desired size.

2. With a craft knife, cut a small slit or notch on each end at opposite edges of the base.

3. Catch the end of the wire in one notch. Wrap the wire around the base from one end to the other, and then catch it in the other notch. Cut the wire. Both wire ends should be on the same non-printing side of the base.

4. Press the wire wrapped block on the stamp pad or into a layer of paint rolled onto the Plexiglas.

5. With craft foam under the paper to act as a printing cushion, press the wire wrapped block onto the paper applying pressure.

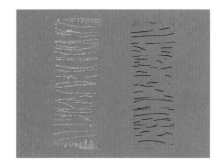

Yellow was stamped with paint, black was stamped using a stamp pad.

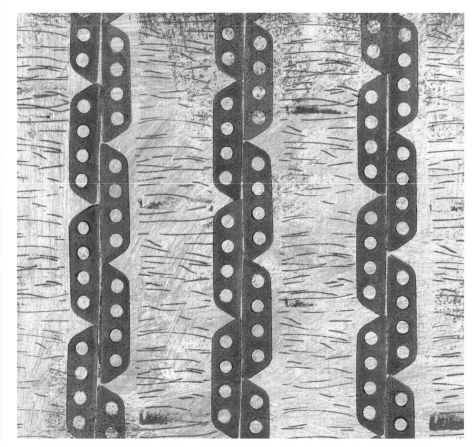

Cardstock was first lightly covered with gesso, and then stamped with a purple stamp pad using the foam bit caddy (Lab 8) and with a red stamp pad using the wire wrapped block.

Tip

Only the highest points of the wires will print. If not much is printing, try flattening the wire more against the base.

Craft Foam Block

- materials for base, see page 10
- adhesive craft foam
- craft knife and/or decorative-edged scissors
- stamp pad or paint
- brayer and Plexiglas if paint is used
- paper

WHOEVER INVENTED CRAFT FOAM is a genius in my book. It can be used for many things and in many ways. Adhesive craft foam is even better because it's ready to be attached to something, yet it's still easy to cut. Years ago I bought some of those scissors that cut decorative edges, but couldn't figure out what to do with them. Then one day I realized they would be perfect for cutting adhesive craft foam that I could then attach to some foamcore for instant custom-made printing blocks. These two blocks used scallop-edged scissors and a craft knife. You can either draw out your design first on the craft foam with a magic marker, or do like I did and just wing it!

Stamped using stamp pads on kraft cardstock.

Instructions

1. Cut the base to the desired size.

2. Cut shapes out of the craft foam using a craft knife or scissors.

3. Peel off the adhesive backing and attach the foam to the base.

4. Press the craft foam block on the stamp pad or into a layer of paint rolled onto the Plexiglas and stamp onto the paper.

Stamped using a stamp pad.

An old book page was first brayed with blue paint (Lab 29), printed with orange and black paint using the craft foam blocks, and then stamped using a black stamp pad with the foam cube stamp molded with washers (Lab 28).

Tips

- Because the craft foam is absorbent, it will need quite a bit of stamp pad ink at first to make a solid print. It doesn't absorb paint as much.

- If you are too lazy to cut out your own designs, you can buy all kinds of shapes of adhesive craft foam in the kid's section of craft stores! (I'm not judging—I found some fun skull shapes.)

Foam Beads Block

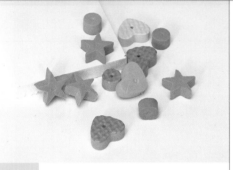

Materials

- materials for base, see page 10
- double-stick tape
- scissors or craft knife
- foam beads
- stamp pad or paint
- brayer and Plexiglas if paint is used
- paper

FOAM BEADS ARE ONE OF THE MANY FUN ITEMS you can find in the kid's section of a craft store or a dollar store that can be used for printing and stamping. They come in a mixed container of basic shapes like stars, squares, and different sizes of circles. Even with the limited variety in the shapes, the design possibilities are endless. Because they are flat, they are easily attached with double-stick tape to a base, and you can arrange them any way you please. By design, they act as their own cushion, making them easy to print with. As a bonus, they usually come with one side textured and the other side smooth. You can also poke out the centers (meant for stringing) so the shapes will print with small centered holes.

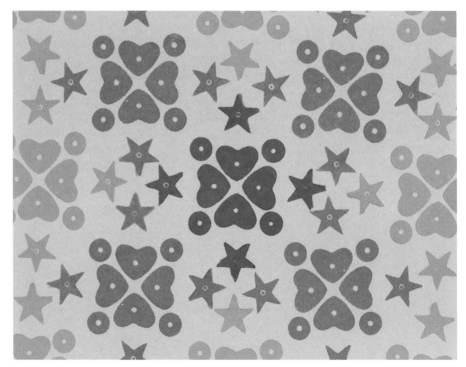

Stamped using stamp pads on cardstock.

Instructions

1. Cut the base to the desired size.

2. Cover one side of the base with double-stick tape and trim.

3. Arrange the beads on the adhesive and press down firmly to attach.

4. Press the foam bead block on the stamp pad or into a layer of paint rolled onto the Plexiglas and stamp onto the paper.

Cardstock was first printed with stamp pads using the wire wrapped block (Lab 13), then stamped with stamp pads using the foam beads block and a craft foam block of stars (Lab 14).

Stamped using a stamp pad.

Tip

These beads are made with moldable foam and can be impressed with textured designs. See unit 2: "Moldable Foam Stamps."

Flip-Flops

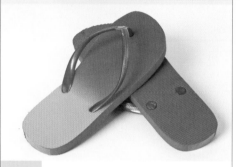

- flip-flops
- craft or utility knife with sharp blade
- cutting mat
- stamp pad or paint
- brayer and Plexiglas if paint is used
- paper

I'VE NEVER BEEN A FAN OF WEARING FLIP-FLOPS, or thongs as they were called when I was a kid. But while scavenging for alternative tools, I realized that they come with different textural patterns on the bottom. It was a lightbulb moment—they could be used for printing, they wouldn't need to be mounted because they were fairly thick and therefore easy to grip, and they could easily be cut with a craft knife. After my first flip-flop print, I looked for flip-flops in every store, hoping to find new and interesting designs on the soles. I struck pay dirt when I found the pair used here because the tops had a different texture than the bottoms! I like the rounded ends at the heels, so I kept them as part of the printing block.

Stamped using stamp pads on cardstock using both sides of the flip-flop.

Instructions

1. Cut a flip-flop to the desired size as you would for a foamcore or rubber stamp mounting foam base.

2. Press the flip-flop block on the stamp pad or into a layer of paint rolled onto the Plexiglas (or roll the paint onto the flip-flop with the brayer) and stamp onto the paper.

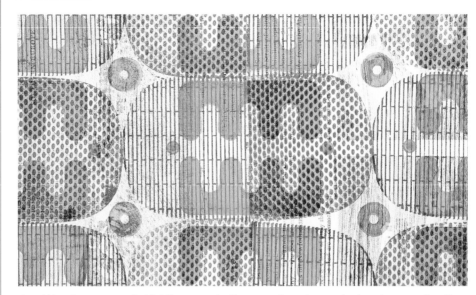

An old book page was first lightly covered with gesso, then stamped using stamp pads with both sides of the flip-flop, corn cushions (Lab 6), and toe spacer foam (Lab 7).

Stamped using a stamp pad.

Print showing the difference between printing with a stamp pad and paint. The left print used a stamp pad, and the right used acrylic paint.

Tips

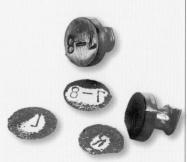

- Circle stamps can be made from the bottom of the flip-flop straps. Cut the straps from the flip-flop at the base and push the end through the bottom. Trim, leaving a little handle for stamping. The circles usually have a raised imprint of the size of the flip flop and "R" and "L." They will print backward, but still make an interesting stamp.

- Buy the largest size you can. The bigger the flip-flop, the more printing blocks you can make.

- Flip-flops also work well as a base to mount items on.

- Flip-flops are also used as moldable foam in **Lab 26** and impressed with textured designs.

Ponytail Holders Block

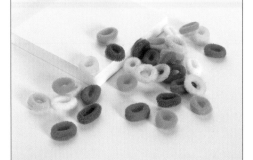

WHEN I SPOTTED THESE PUFFY PONYTAIL HOLDERS in the dollar store, I thought they looked like little round caterpillars. I also thought they would be interesting to print with, not only because of their texture but also because they are so malleable. I was happily surprised when I saw how their texture printed. Any kind of ponytail holders would work. Glue them to a base, changing their shapes if you wish. Have fun experimenting with different shapes, sizes, and textures for different results.

Materials

- materials for base, see page 10
- glue
- ponytail holders
- wax paper
- book or flat weight
- brayer
- paint
- Plexiglas
- paper

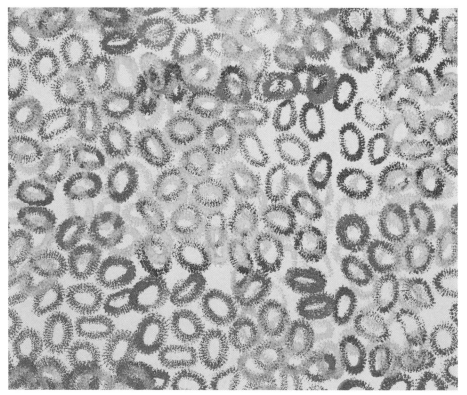

Stamped using paint on cardstock.

Instructions

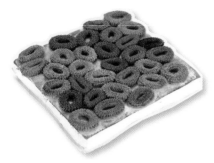

1. Cut the base to the desired size.

2. Cover one side of the base with glue.

3. Randomly place the ponytail holders on the adhesive, changing their shape if desired.

4. Cover with a piece of wax paper and place a book or flat weight on top of the base until the glue is dry to ensure good contact. The wax paper protects the weight from any excess glue.

5. Charge the brayer with paint, then roll it onto the ponytail holders block, or press it directly into paint that has been rolled out onto a piece of Plexiglas.

6. Press the ponytail holders block onto the paper, applying pressure, and then remove it.

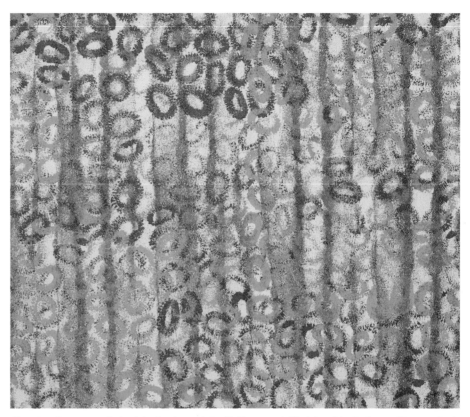

Construction paper first printed using paint with the ponytail holders block, then with a melted foam pipe insulation roller (Lab 35).

Stamped using paint.

Tips

• For the specific kind of ponytail holders that I used, stamp pads do not work very well for printing. You'll need to experiment with the kind you are using to see what works best.

• Experiment with applying more than one color of paint at a time onto the block.

DIE CUT FELT CAN BE FOUND IN CRAFT STORES and dollar stores in the form of ornaments, coasters, and even scrapbooking trim. These items come in different shapes with various designs cut out of them. Ornaments and coasters are usually large, bold designs, but the ones used for scrapbooking can be quite ornate and usually have adhesive on the back. The felt prints a texture similar to a woodblock print. Keep an eye out for stars and hearts around Valentine's Day and Christmas! Ornaments and coasters don't need to be mounted. Scrapbooking pieces are thin, but they have an adhesive backing, so they are easily attached to a base. They come in long pieces, so cut them into a shorter, more manageable size for printing.

Materials

- die cut felt pieces
- materials for base (for scrapbooking die cut felt), see page 10
- brayer
- paint
- Plexiglas
- paper

Printed using paint.

Printed using paint on cardstock.

Instructions

For scrapbooking piece only:

1. Cut the felt piece and base to the desired size.

2. Remove the adhesive backing and attach the felt piece to the base.

3. Charge the brayer with paint, and then roll it onto the felt.

4. Press the felt block onto the paper, applying pressure, and then remove it.

For unmounted felt pieces:

1. Charge the brayer with paint, then roll it onto the felt.

2. Press the felt piece onto the paper.

3. Apply pressure using your hands; move them around to ensure that every part is printed, but be sure not to move the felt.

4. Slowly lift up a corner or section at a time, checking to see if any part needs to be pressed down on the paper again and reworked.

5. Remove the felt while holding the paper down.

Cardstock was first printed with blue paint using a wire wrapped dowel (Lab 34), printed with paint using the die cut felt pieces, then stamped with a stamp pad using a carved star novelty eraser (Lab 21).

Tips

- Because the felt is absorbent, it will need quite a bit of paint at first to make a solid print. Allowing the paint to dry on the felt will make it easier for printing the next time, and not as much paint will be needed.

- If using foamcore as the base for a scrapbooking felt piece, trim off the excess edges of the base to make it easier to position when printing. This will also eliminate areas of the base printing, but might still happen because the felt is so thin.

- Die cut felt is also used as stencils in **Lab 50**.

Plexiglas Printing

- brayer
- paint
- Plexiglas
- foam stamp
- paper

PRINTING WITH A PIECE OF PLEXIGLAS is the opposite of stamping. Basically, a foam stamp is used to remove the paint that's been rolled onto a piece of Plexiglas, leaving the negative areas of paint to print a reversed image. This type of printing creates a lovely rustic or aged look. Use a foam stamp so that it can soak up the paint. I've found that medium to thick paints work best because thin, runny paints won't hold the image. Keep in mind you won't get a crisp print using this technique. Instead you'll get a nice worn, antique look.

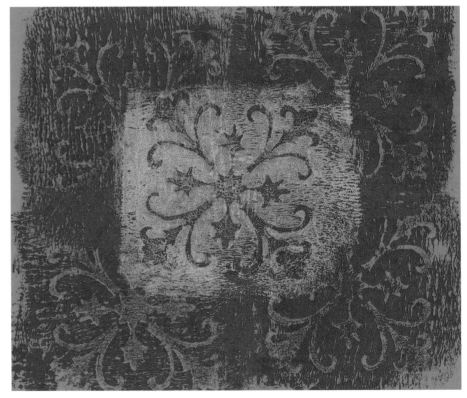

Printed using paint on cardstock.

Instructions

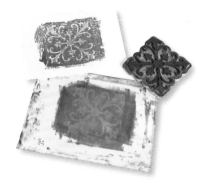

1. With a brayer, roll a thin layer of paint onto the Plexiglas.

2. Press a foam stamp into the paint on the Plexiglas and lift up.

3. Place the printing paper face down onto the Plexiglas and rub over the whole area with your hand, pressing the paper into the paint. Alternatively, place the Plexiglas paint-side down onto the paper and press down, making sure the whole area of Plexiglas makes contact with the paper. Doing it this way makes it easier to position on the paper.

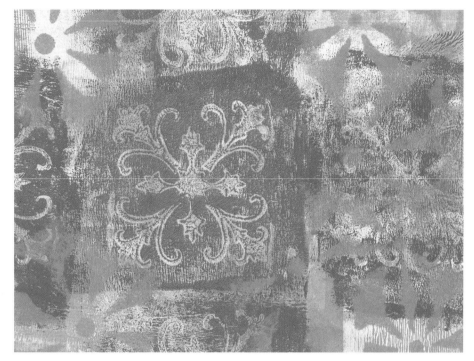

Cardstock was first lightly covered with gesso, printed with brown paint in a plus shape using the Plexiglas and foam stamp, then stenciled with ochre paint in the corners using a die cut felt place mat (Lab 50).

Printed using paint and a commercial foam stamp.

Tips

- Before stamping again into the paint for the next print, stamp onto a piece of scrap paper to remove the paint. That way, more paint can be absorbed and removed from the Plexiglas.

- To print a vignette with a soft edge around the print, don't rub as hard around the edges of the paint.

- You can use either commercial foam stamps from the craft store or make your own using craft foam as in **Lab 14**.

- Before making another print, roll more paint onto the Plexiglas.

Foam Plates

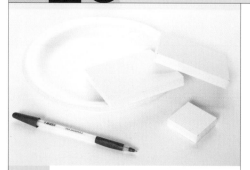

- craft knife and/or scissors

- cutting mat

- foam plates, tray, or containers

- ballpoint pen

- materials for base, see page 10

- double-stick tape

- stamp pad or paint

- brayer and Plexiglas if paint is used

- paper

MAKING PRINTING TOOLS FROM FOAM PLATES and trays is a way to reuse them and keep them out of the landfill. Foam take-out containers, meat trays, and plates will all work well. This technique is easy enough that kids can join in and learn about repurposing things at the same time. All that's needed to make the printing plate besides the foam is a ballpoint pen and a pair of scissors or a craft knife. The design is created by drawing on the foam with the pen, breaking the surface of the foam. The drawn design will not print, but the unblemished areas will, creating a reversed image. The foam can also simply be cut into shapes using a craft knife. I like to combine the two, drawing a design and then cutting it out. These printing plates can be used unmounted, but are easier to use when mounted to a base.

Stamped on cardstock using red and green stamp pads and blue paint.

Instructions

1. Cut the lip off of the foam plate, leaving only the flat part to work on.

2. With a ballpoint pen, draw a design onto the foam, breaking the surface but being careful not to go all the way through. (Skip this step if you want a cut-out shape without a design drawn inside it.)

3. Cut out the outer edge of your design.

4. Cut the base to the desired size.

5. Cover one side of the base with double-stick tape and trim.

6. Press the foam shape on the adhesive, being careful not to damage the surface.

7. Press the foam block on the stamp pad or into a layer of paint rolled onto the Plexiglas and stamp onto the paper.

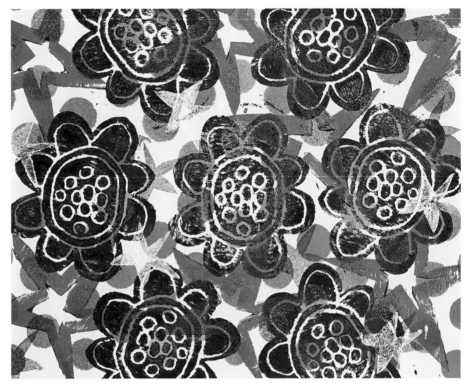

Cardstock was first stenciled using different colors of paint with a plastic basket (Lab 48), and then printed using the foam plates with black, magenta, and gold paint. The small star was also stamped using a purple stamp pad.

Stamped using paint.

Tips

- If the paint is too thick on the Plexiglas, it will clog up areas of the design and won't show when printed.

- If using foamcore for the base, trim off the excess edges to make it easier to position when printing. This will eliminate areas of the base printing, but it's impossible to keep this from happening because the foam is so thin.

Carved Novelty Erasers

IT'S FUN TO CARVE YOUR OWN STAMPS. The best part can be using inexpensive erasers for the carving material. Novelty erasers not only have designs printed on them but also come in fun shapes, in multiples, and can be found in the dollar store. This makes it really easy if you want to carve your own stamps but don't know what to carve. Just follow the printed design! If the image printed on the eraser is too complicated, simplify it by carving only the main shapes. Keep in mind that what is carved away will not print, and what isn't carved will. Start with something simple for your first stamp to get the hang of it. It isn't necessary to carve very deep, and it's better to go slowly. If you mess up, just start with a new eraser.

Materials

- carving handle and blade (blades are also called cutters). The smallest V-shaped cutter (#1) is the main cutter used. The bigger cutters are for cutting out backgrounds. (See "Equipment," page 18)

- novelty erasers

- stamp pad

- paper

Randomly stamped on cardstock with stamp pads.

Stamped using a stamp pad.

Instructions

1. Holding the carving tool like a pencil, and carving away from yourself, carve an outline around the entire design on the eraser using the #1 blade.

2. After the entire design is outlined, try out the stamp by pressing the carved side of the eraser on the stamp pad and stamp onto the paper.

3. Look at the stamped image and decide what lines need to be cleaned up. After making any changes, try out the stamp again.

4. Carve away more of the eraser, leaving the areas you want to print. When carving away the background, a larger cutter can be used.

5. Keep working and testing the stamp until you are happy with the stamped image.

Cardstock was first printed using a green stamp pad with a vinyl covered dowel (Lab 40), then stamped in columns using stamp pads with carved novelty erasers.

Tips

- Paint can be used with carved erasers but might clog up fine lines. Be sure to wash off the paint before it dries.

- Carve away from yourself, turning the carving block instead of the tool.

- If there is a large area to carve out, it's better to carve a little at a time than to try to get it all at once.

- When carving out backgrounds, don't carve it all out. Leaving a few small lines will give a hand-carved look.

Moldable
Foam Stamps

MOLDABLE FOAM IS FOAM WITH A SUPER POWER. After being heated up, it takes on the texture of whatever it is pressed against, and it keeps the impression until it's reheated and remolded. I take advantage of this power to make my own moldable foam stamps using everything imaginable for the textures: crumpled paper, rubber bands, rice, safety pins, paper clips, and buttons, to name a few.

Although you can buy foam that is made specifically for this purpose, there are all kinds of foam hiding out as other items like flip flops, alphabet bath toys, and garden kneeling cushions, and they are often less expensive! Aside from the moldable foam and something with texture, the only other thing needed is an embossing heat tool (see "Equipment," page 18). A hair dryer won't work because it doesn't get hot enough. Simply heat up the foam, and then press it against something with texture for 10 to 15 seconds. As the foam cools, it keeps the texture of whatever it's pressed against.

UNIT

2

Keep in mind that the embossing heat tool blows out very hot air, so don't hold the foam with your hand while heating it up! Lay it on a flat surface that won't be damaged from high heat.

The larger the piece of foam, the harder it is to get it evenly heated up and the harder it is to apply even pressure to get it evenly molded. For that reason, it's best not to make anything over 4" × 4" (10 cm × 10 cm). It also helps to put a wood block or book on top of everything to help apply even pressure. Experiment to see which order works best—pressing the heated foam down onto the textured items, or sandwiching the textured items between the heated foam and a piece of wood. You have to act quickly, though—if the foam cools, it won't take on the impression. But just heat it up again and give it another try. The smaller a piece of foam, the less time it takes to heat. It generally can take about 10 to 20 seconds to heat the foam enough to mold it.

Stamp pads with moldable foam work better than paint because the prints show more detail. And you can get an incredible amount of detail with moldable foam. Plus, even if the foam is cleaned well after using it with paint, the paint causes the foam to harden over time, making it so it can't be remolded.

The labs in this unit use specific foam pieces and items to make the textures. They are meant to give you an idea of how it all works. Feel free to try anything made of foam using different items to create the texture. Before starting, read the "Basics" chapter starting on page 10. This has important information on acrylic paints, stamp pads, printing, and equipment.

Tips

- When molding a large piece of foam, place a wood block or book on top of the foam while pressing against the textured item to help apply even pressure.

- If the impression on the foam doesn't turn out, reheat it and try again.

- The smaller a piece of foam, the less time it takes to heat.

- Stamp pads work best with moldable foam because the print shows more detail. Even if the foam is cleaned well after using it with paint, the paint causes the foam to harden over time, making it so it can't be remolded.

Foam Marshmallows

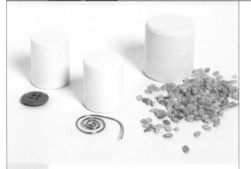

- pliers and wire cutters
- 18- or 20-gauge wire
- uncooked rice
- button (slightly smaller than the marshmallow)
- foam marshmallows
- embossing heat tool
- stamp pad
- paper

EVERY TIME I GO TO THE CRAFT STORE, I scour the kid's section to see what new, fun things there might be that I hadn't seen before. I was intrigued the first time I saw a package of what looked like white marshmallows made out of foam. They are normally used to create little snowmen and similar items. As soon as I squeezed one, I knew what I'd be using them for—making moldable, circular stamps. The foam these marshmallows are made of is excellent moldable foam, and can make very detailed stamps. So far, I have found them in two sizes! This lab demonstrates three different items that can be used to mold the stamps, but anything can be used.

Randomly stamped on cardstock with stamp pads.

Instructions

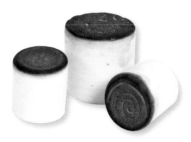

1. Using the pliers and wire, create a flat spiral or other design that is smaller than the top of the marshmallow. Cut the wire at the end of the spiral or design with the wire cutters.

2. Lay out the rice, button, and wire design on a hard, flat surface.

3. *Standing a foam marshmallow upright, heat the top with the embossing heat tool for approximately 10 seconds.*

4. Using even pressure, press the heated top of the foam marshmallow firmly against one of the items for 5 to 10 seconds.

5. Press the molded side of the marshmallow on the stamp pad and stamp onto the paper.

6. Repeat with the other marshmallows using the other items to make the impression.

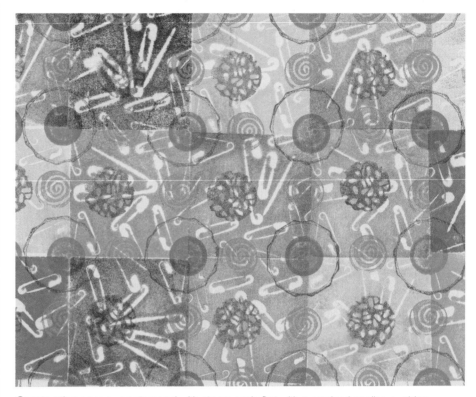

Construction paper was stamped with stamp pads first with a garden kneeling cushion molded with safety pins (Lab 27), with the foam marshmallows in repeating columns, then with a large cap (Lab 2) using a brown stamp pad.

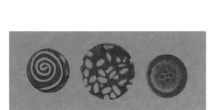

Stamped using a stamp pad.

Tips

- Both ends of the foam marshmallows can be molded separately. They are tall enough that when the second end is being heated, it won't affect the first end that has already been molded.

- Foam marshmallows can also have a design incised into them to be used as printing rollers (Lab 38).

Alphabet Bath Toys

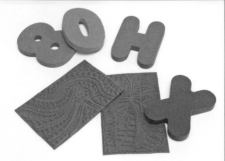

- foam alphabet bath toys
- embossing heat tool
- textured rubber sheets
- stamp pad
- paper

BEING FAMILIAR WITH MY MOLDABLE STAMPS, a friend introduced me to children's alphabet foam bath toys. They work perfectly and can easily be cut if you don't want to use them in the letter or number shape. I usually keep them in their original form because the stamped image of the letter or number isn't as obvious once it's molded and stamped in a random or repeating pattern. As you can see, I'm particularly fond of the o's, x's and 8's. The toys are thick enough that they can be used without having to mount them onto a base. You can use found objects, rubber stamps, or textured rubber sheets that are normally used for texturing polymer clay to create impressions on the foam. The textured rubber sheets used for this lab are from my own design line and were made from my original drawings (see "Resources" on page 142).

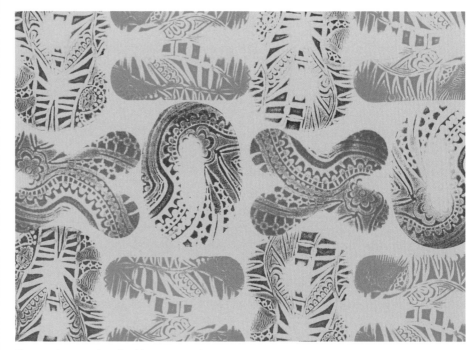

Stamped on cardstock with stamp pads.

Instructions

1. Heat the top of the foam toy with the embossing heat tool for approximately 10 seconds.

2. Using even pressure, press the foam letter firmly against a rubber texture sheet for 10 to 15 seconds.

3. Press the molded side of the foam letter on the stamp pad and stamp onto the paper.

4. Repeat with the other foam letters using different textured rubber sheets or different parts of the sheets to make the impression.

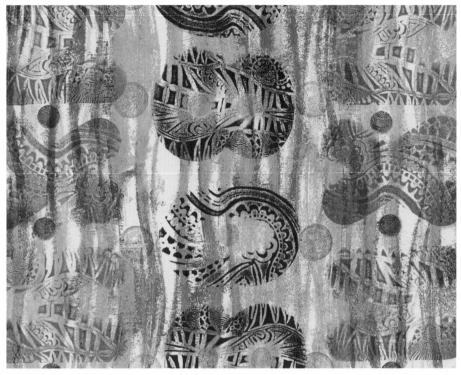

Cardstock was first printed using red and yellow paint with a melted foam pipe insulation roller (Lab 35), stamped using stamp pads with foam letters, then with earplugs and corks (Lab 1).

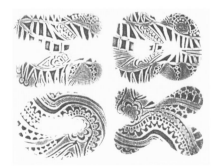

Stamped using a stamp pad.

Tips

- Some bathtub letters are smooth on both sides, and some come with a texture on the back. Sometimes the textured side can be molded, and sometimes it can't. But because the letters are too thin to mold the second side without affecting the first side already molded, this isn't really an issue.

- Don't place the textured rubber sheets near the heat embossing tool because the heat can damage the rubber.

- craft knife or utility knife with a sharp blade
- cutting mat
- cork-backed steel ruler
- foam play mat
- fence staples
- embossing heat tool
- stamp pad
- paper

KID'S PLAY MATS ARE LITTLE FOAM SQUARES with interlocking edges. They come twelve to a package. Now that's a lot of stamp-making material! The top is usually printed with something from a kid's cartoon or movie, and the back is plain. The play mat is too thin to mold both sides, so I just use the plain side. Sometimes the printing on the foam can interfere with molding it (but sometimes not, depending on the foam). The foam play mats that I use don't hold a lot of detail and start to lose the design after some time. I'm not sure if this is from repeated cleaning or from humidity. But it's okay because the mats can be remolded when they start to loose their oomph. With this lab, I used fence staples from my local hardware store to make the impression, but anything bold can be used.

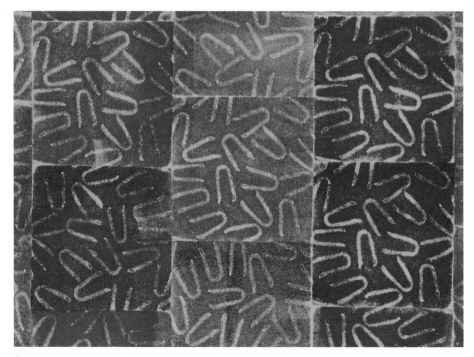

Stamped on cardstock with stamp pads in a brick pattern.

Instructions

1. Using a craft knife, cutting mat, and steel ruler, cut the play mat to the desired size as you would for a foam-core or rubber stamp mounting foam base; cut off the interlocking edges to create a straight edge.

2. Lay out the fence staples randomly or in a desired pattern.

3. Heat the plain side of the play mat with the embossing heat tool for 10 to 15 seconds.

4. Using even pressure, press the play mat firmly against the fence staples for 5 to 10 seconds.

5. Press the molded side of the play mat on the stamp pad and stamp onto the paper.

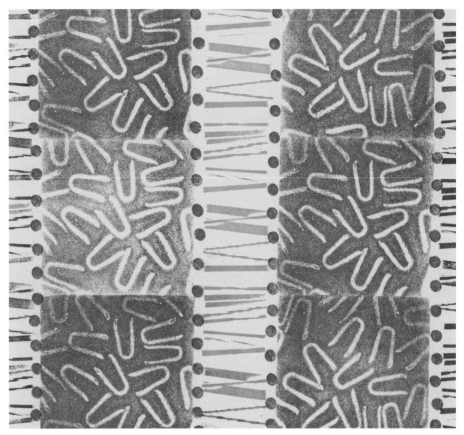

Stamped using stamp pads on construction paper first with the play mat, then with a rubber band block (Lab 12) and a pencil eraser (Lab 4).

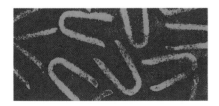

Stamped using a stamp pad.

Tip

If you are using the whole piece of play mat, it's easier to mold and print with if it's attached to a thin piece of foam core. It can easily be attached using double-stick tape.

LAB 25 Chunky Stamps

Materials

- crumpled paper
- rubber bands
- textured piece of stained glass
- chunky foam stamps
- embossing heat tool
- stamp pad
- paper

CHUNKY FOAM STAMPS ARE READILY FOUND in craft stores or craft sections of department stores. They are inexpensive and come in many different shapes and sizes. Not only can you use them as they are, but you can also spice them up and give them more character by molding them onto something textured. It's like when you buy a frozen cheese pizza and make it tastier by adding your own ingredients. This lab demonstrates using crumpled paper, rubber bands, and textured stained glass to make the impressions, but anything can be used.

Stamped on cardstock with stamp pads.

Instructions

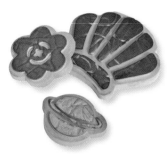

1. Lay out the crumpled paper, rubber bands, and textured piece of stained glass on a hard, flat surface.

2. Heat the top of a chunky stamp with the embossing heat tool for about 10 seconds.

3. Using even pressure, press the chunky stamp firmly against one of the items for 10 to 15 seconds.

4. Press the chunky stamp on the stamp pad and stamp onto the paper.

5. Repeat with the other stamps using the other items to make the impression.

Stamped using a stamp pad: Saturn was molded using crumpled paper, the flower was molded with the textured piece of stained glass, and the shell was molded with rubber bands.

*Stamped using stamp pads on cardstock paper first with the chunky stamps, then with corn and bunion cushions (**Lab 6**) and a furniture leg cup (**Lab 5**).*

Tips

- Smaller chunky stamps have a thinner piece of foam that is used for the design shape. When molding these stamps, don't use too much pressure or you'll flatten out and distort the shape.

- Look for chunky stamps on clearance. Sometimes you can find boring stamps that are really cheap and mold them to be more interesting.

LAB 26 Flip-Flops

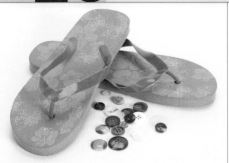

Materials

- craft knife or utility knife with a sharp blade
- cutting mat
- cork-backed steel ruler
- flip-flops
- buttons
- embossing heat tool
- stamp pad
- paper

THE FOAM USED FOR MOST INEXPENSIVE FLIP-FLOPS makes incredibly wonderful molded stamps. It takes on great detail, the thickness makes it easy to handle when printing, and it cuts easily with a sharp craft knife. And, you can make quite a few moldable stamps from one pair. An added bonus is that the bottom comes with a textured pattern ready to be stamped. Usually the bottom can't be molded because of the texture, so I use it to stamp as is and only mold the top side. Flip-flops can be hard to find in the winter, so stock up when they're in season. Get them at dollar stores or on clearance at department stores. This lab demonstrates using buttons to mold the flips-flops, but anything can be used, even if it has a lot of detail.

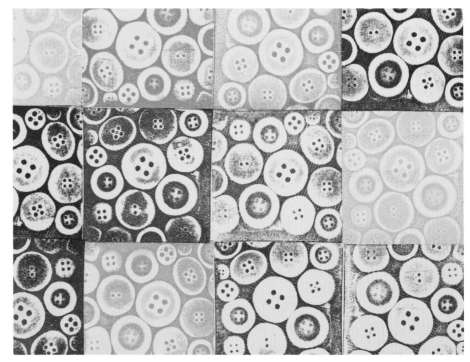

Stamped on cardstock with stamp pads.

Instructions

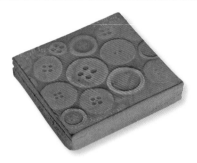

1. Using a craft knife, cutting mat, and steel ruler, cut a flip-flop to the desired size as you would for a foamcore or rubber stamp mounting foam base.

2. Lay out the buttons on a hard surface in the desired arrangement.

3. Heat the surface of the flip-flop with the embossing heat tool for 10 to 15 seconds.

4. Using even pressure, press the flip-flop block firmly against the buttons for 5 to 10 seconds.

5. Press the molded flip-flop block on the stamp pad and stamp onto the paper.

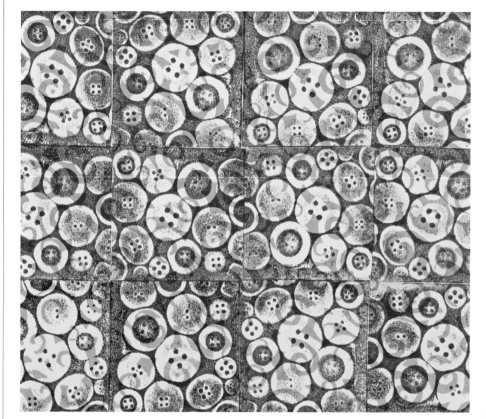

Stamped using stamp pads on watercolor paper that was first stenciled using green paint with a scrapbooking die cut paper (Lab 46).

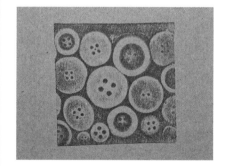

Stamped using a stamp pad.

Tips

- Buy the largest size flip-flops you can find to get more bang for your buck. The bigger the flip-flop, the more printing blocks you can make.

- It's important to use a sharp blade when cutting the flip-flop. Otherwise, the block won't print a clean edge.

Garden Kneeling Cushion

- craft knife or utility knife with a sharp blade
- cutting mat
- cork-backed steel ruler
- garden kneeling cushion
- safety pins, assorted sizes
- embossing heat tool
- stamp pad
- paper

GARDEN KNEELING CUSHIONS work great as moldable foam stamps. Quite a few stamps can be made from one cushion, and they are easy to cut with a craft knife. Plus, they don't need to be mounted because they are thick enough to grip while printing. All kneeling cushions are not made out of the same material, and some cannot be molded. Typically, the cheaper the cushion, the better it molds. The nicer, more expensive ones are firmer and usually won't work. If the cushion is fairly spongy, it will probably work fine. Keep in mind that they are seasonal items and are easiest to find in spring and summer.

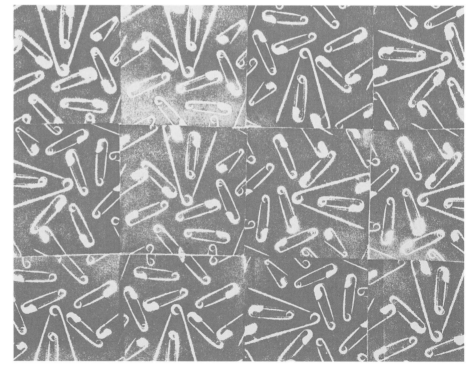

Stamped on construction paper using stamp pads.

Instructions

1. Using a craft knife, cutting mat, and steel ruler, cut the garden kneeling cushion to the desired size as you would for a foamcore or rubber stamp mounting foam base.

2. Lay out the safety pins on a hard surface in the desired arrangement.

3. Heat the surface of the garden kneeling cushion with the embossing heat tool for 10 to15 seconds.

4. Using even pressure, press the kneeling cushion block firmly against the safety pins for 5 to 10 seconds.

5. Press the molded cushion block on the stamp pad and stamp onto the paper.

*Cardstock was first brayed with metallic paint (**Lab 29**), and then stamped using stamp pads with the kneeling cushion block and both sides of a furniture leg tip (**Lab 5**).*

Stamped using a stamp pad.

Tip

Both sides of the garden kneeling cushion can be molded with designs.

Foam Cube Stamp

I LIKED THE IDEA of those big foam cube stamps that have a design on almost all of the sides, but the designs weren't really my style. I bought some anyway, knowing I could figure out some way to use them that was more in line with my style of artwork. While playing around with them, some of the little foam designs started coming off, and I realized I could take off the foam designs and use the base cube as moldable foam. The size was perfect, and the designs came off easily. The cube was big enough that after molding one side, the opposite side could be molded without the heat disturbing the first side.

- foam cube stamp
- paper clips, assortment of sizes
- washers, assorted sizes
- embossing heat tool
- stamp pad
- paper

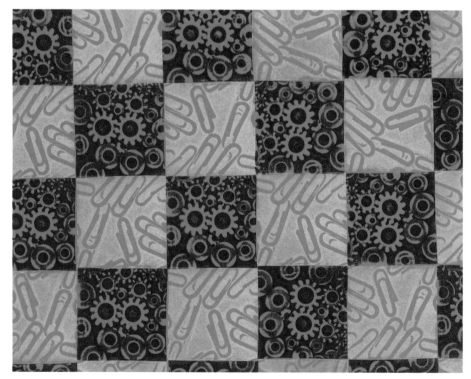

Stamped on cardstock with stamp pads in a checkerboard pattern, alternating the two sides.

Instructions

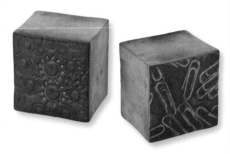

1. Carefully pull the foam designs off the foam cube base.

2. Lay out the paper clips and washers on a hard, flat surface in the desired arrangement.

3. Heat one side of the foam cube with the embossing heat tool for 10 to 15 seconds.

4. Using even pressure, press the heated side of the cube firmly against the paper clips for 5 to 10 seconds.

5. Press the molded cube on the stamp pad and stamp onto the paper.

6. Repeat with the opposite side of the cube using the washers to make the impression.

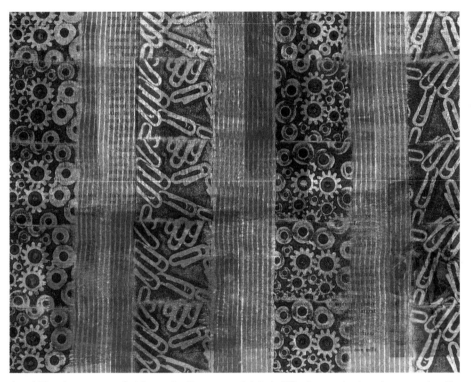

*An old book page was first brayed with green paint (**Lab 29**), stamped using stamp pads with the foam cube stamp, and then printed using stamp pads with pencil grip rollers (**Lab 30**).*

Stamped using a stamp pad.

Tips

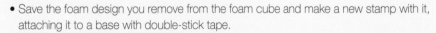

- Save the foam design you remove from the foam cube and make a new stamp with it, attaching it to a base with double-stick tape.

- Only two opposing sides of the cube can be molded. The heat from trying to mold a third side would heat up the two sides already molded, making those impressions disappear.

- Use one of the unmolded sides of the cube to stamp a solid square.

Rollers

ROLLERS WITH DESIGNS ON THEM will print a continuous image. Although it may sound complicated, the tools range in complexity from simply putting a pencil grip onto a pencil to carving a design on a brayer.

Like most of the tools in this book, rollers are created mainly from simple items that can be found around the house. A few items are more specialized, but all of them are inexpensive. All of the items were originally meant to be used differently than they are used here. Although each lab uses specific items to create the rollers, they are meant to be a springboard, inspiring you to try new items as materials for printing rollers.

Printing with rollers is a great way to quickly cover a page or an item for a background, but the images are also interesting enough to be the main focus of a print. Because the diameter of all the rollers is small, they may run out of paint or ink before printing an entire page. After the full circumference of the roller is printed, the design will get fainter. Depending on the design or tool, sometimes it's best to stop printing as soon as the roller begins to print lighter, recharge the roller with paint or ink, and then match it up with the print to continue. With simple designs you may just continue printing after recharging the roller without trying to match up the design. A printed image getting lighter as it continues can also be used as a design element, creating interesting light and dark effects.

Most of these labs can be printed with either paint or stamp pads, with different results. Before starting, read the "Basics" chapter starting on page 10. This has important information on acrylic paints, stamp pads, printing, and equipment.

How to Make a Roller Base from a Wooden Dowel

1. Using a saw, cut a piece of wooden dowel to the desired length. (Most of the dowels used in these labs are about 3" [7.5 cm] long.)

2. With sandpaper, sand any rough edges on the ends.

3. Mark the center of each end of the dowel and hammer a finishing nail into the center of each end, leaving enough of the ends of the nails exposed to use as handles.

Tips for Making the Roller

- Use finishing nails because they have brad heads, or rounded heads, that are easy on your hands. Regular nails that look like a T might tear your skin.

- It can be tricky nailing in the second nail. Find something that the first nail in the dowel can fit inside or between while hammering in the second nail. For example, use a vice or put two thick books that are the same height next to each other with the nail between the books.

Tips for Printing

- With tools that list paint or stamp pads in the materials section, both work equally well for printing. Stamp pads show more detail but provide a lighter print.

- When the roller begins to print lighter, recharge the roller with paint or ink and continue printing. Depending on the design, sometimes the design on the roller can be matched up with the print to continue printing. Many times matching it up isn't necessary.

- If the print is too light, especially when using a stamp pad, place a sheet of craft foam under the paper to act as a printing cushion.

Brayer

BRAYERS ARE USED NORMALLY IN PRINTMAKING to roll a layer of paint onto a palette or to apply paint onto a printing block. They are also used in collage to roll back and forth over glued papers to ensure good contact. Here we use a brayer to print with. Applying paint onto paper or another surface with a brayer is not only a fast way to cover the surface, but it also results in an interesting texture caused from the tension between the brayer roller, paint, and paper, especially when there isn't too much paint on the brayer, or when the paint is tacky. Although a brayer with a foam roller can be used, it won't have the same effect as a brayer with a rubber roller.

Materials

- paint
- Plexiglas
- brayer
- paper

Printed on colored cardstock using green and white paint applied in stripes. The white paint was rolled horizontally, and the green paint was rolled vertically, leaving strips of paper unprinted.

Instructions

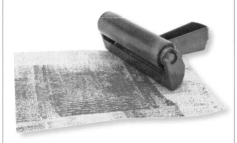

1. Squeeze a small amount of paint about the size of a quarter onto the Plexiglas.

2. Roll the brayer back and forth over the paint until the roller is evenly covered with paint.

3. Roll the brayer across the paper.

Orange cardstock was first lightly covered with gesso, brayed with green paint, printed with red paint using an incised foam pipe insulation roller (Lab 37), then stamped using a stamp pad with a pencil eraser (Lab 4).

Printed using paint.

Tips

- Thin acrylic paints can be used for printing with brayers, but they won't create the same kind of texture as thicker paints will.

- Use metallic paints to quickly create sparkly backgrounds with brayer printing.

Pencil Grips

- pencil grips
- pencil
- stamp pad or paint
- brayer and Plexiglas if paint is used
- paper

PENCIL GRIPS ARE MULTIPURPOSE CREATURES. Besides their normal use, they also make great printing rollers. All that is needed is a pencil and a stamp pad or some paint. In addition to the normal foam pencil grip, there are also novelty pencil grips that are geared toward kids. They have different textures, making them interesting to use as printing tools. Whether using a foam pencil grip that prints a solid band or a novelty pencil grip that prints stripes or diagonals, they all print a column the width of the pencil grip. The width that is printed can easily be made narrower by cutting the pencil grip with scissors or a craft knife. Yet another talent of the pencil grips is that they can be used to stamp with (Lab 3).

Printed on watercolor paper using stamp pads.

Instructions

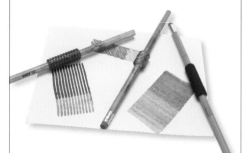

1. Place a pencil grip on the middle of a pencil.

2. Using the ends of the pencil as roller handles, roll the pencil grip on a stamp pad or layer of paint rolled onto Plexiglas, completely covering the roller, and roll onto the paper.

Printed using a stamp pad.

Cardstock was first lightly covered with gesso, printed with stamp pads using the solid foam pencil grip, the diagonally striped pencil grip, and a foam marshmallow molded with a button (Lab 22), then the vertically striped pencil grip was printed over the areas first printed with the solid foam pencil grip.

Tip

If the interior circumference of the pencil grip stretches, causing it to slip on the pencil while rolling, wrap the center section of the pencil with masking tape. That will make the pencil slightly thicker and give the pencil grip a little traction.

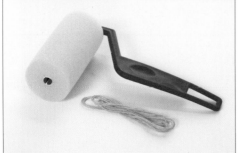

FOAM PAINT TRIM ROLLERS CAN BE EASILY ALTERED to create interesting prints. Take advantage of the sponginess of the foam, and tightly wrap the roller with string. The sponge bulges through the areas that aren't wrapped, and that's the part of the foam roller that prints. This one is wrapped from one end to the other, then back again, crossing over the string where it was already wrapped to create a crisscross effect. This kind of wrapping prints a snake skin–type pattern. Experiment with wrapping in different ways to create different patterns. If you don't like it, just untie the string and rewrap the foam roller. Foam paint trim rollers can be found in hardware stores, dollar stores, or even the kid's section of craft stores. Sometimes you can find packages with one handle and several removable rollers. That makes it possible to create several wrapped rollers while needing only one handle. You can also buy replacement rollers, adding to the roller printing fun.

Materials

- small amount of string
- foam paint trim roller
- scissors
- paint
- brayer and Plexiglas
- paper

Printed on cardstock using paint.

Instructions

1. Using the string, wrap the foam roller tight enough to cause the foam to bulge where it's not wrapped. Cut the string, leaving tails.

2. Tie the ends of the string either to each other or around the roller to keep the string wrapped tightly around the roller.

3. Roll the wrapped paint trim roller on a layer of paint rolled onto Plexiglas, completely covering the roller, and roll onto the paper.

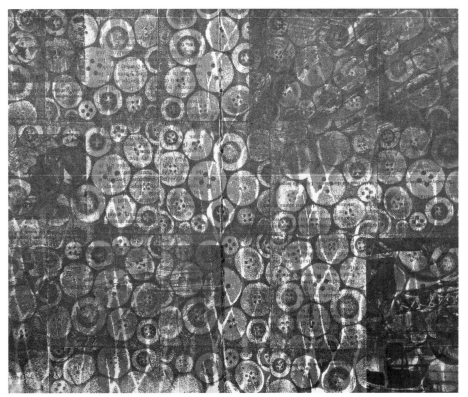

*An old book page was first stamped using a blue stamp pad with a flip flop molded with buttons (**Lab 26**), then printed with red paint using the wrapped paint trim roller.*

Printed using paint.

Tips

- Stamp pads can be used for printing, but the print will be very faint.
- Because the roller is made from foam, the foam will absorb a lot of paint at first. But this also makes it possible to print longer before needing to recharge the roller.
- Rubber bands can also be used to bind the foam roller.

Rubber Band Wrapped Roller

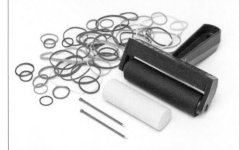

RUBBER BANDS ARE WONDERFUL ITEMS to use for mark making, and they are cheap and plentiful. You can either make a roller from scratch using a dowel with a nail on each end for the handles, or simply take off the roller from a brayer. This lab demonstrates how to do it both ways while also showing the different effects created by wrapping the rubber bands in different directions. Wrapping the rubber bands around the circumference of the roller will print continuous vertical lines, while wrapping the rubber bands so they are horizontal will print a band of horizontal lines. If you don't like the design that is made, simply change the placement of the rubber bands. These rollers can also be used for other things because the rubber bands are easily removed

Materials

- materials for a wooden dowel roller base, 1" (2.5 cm) diameter or wider, see page 81

- rubber bands

- stamp pad or paint

- brayer and Plexiglas if paint is used

- paper

- brayer with removable roller

Printed on cardstock using stamp pads: orange was printed with the rubber band wrapped dowel and green was printed with the rubber band wrapped brayer.

Instructions

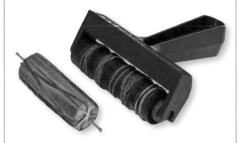

1. Make a roller base using a wooden dowel (see "How to Make a Roller Base from a Wooden Dowel," page 81).

2. Wrap rubber bands horizontally around the dowel, looping them around the nails.

3. Using the nails as handles, roll the rubber band wrapped roller on a stamp pad or layer of paint rolled onto Plexiglas, completely covering the roller, and roll onto the paper.

4. Repeat with the brayer roller, removing the roller and wrapping the rubber bands around the circumference of the roller so they are vertical (but at angles), then putting the roller back on the brayer to print.

Printed using stamp pads.

*Cardstock was first stamped using a brown stamp pad with a rubber band wrapped block (**Lab 12**), then printed using a blue stamp pad with the rubber band wrapped dowel and a green stamp pad with the rubber band wrapped brayer.*

Tip

Rubber bands can also be used to make a rubber band wrapped block (**Lab 12**).

Cord Wrapped Dowel

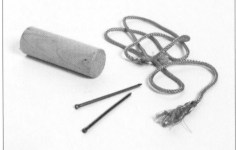

- materials for a wooden dowel roller base, 1" (2.5 cm) diameter or wider, see page 81
- double-stick tape
- cord
- stamp pad or paint
- brayer and Plexiglas if paint is used
- paper

WRAPPING CORD AROUND A BLOCK is a simple way to print continuous vertical lines. Any kind of cord or string will work, but I like to use something with some texture, such as braided cord, because of the added detail. Depending on the type of cord used, either double-stick tape or glue can be used to attach it. Because the cord is wrapped, only the two ends need to be attached. I attached my cord with double-stick tape, and after cleaning it several times, the cord absorbed too much liquid and the ends started to unwrap. I easily remedied this by adding a little glue to reattach the ends after the cord was dry. But I've made other cord wrapped rollers where the double-stick tape held up fine over many uses and cleanings. I recommend starting off with double-stick tape and then adding some glue later if needed.

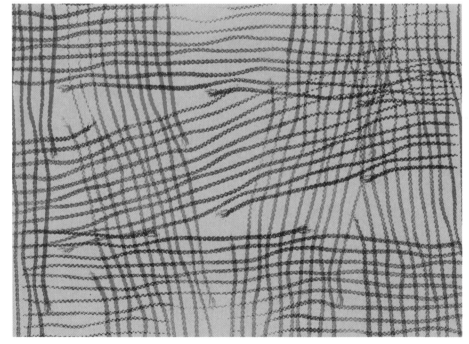

Printed on cardstock using stamp pads.

Instructions

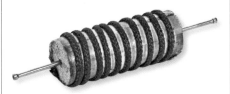

1. Make a roller base using a wooden dowel (see "How to Make a Roller Base from a Wooden Dowel," page 81).

2. Cover the dowel with double-stick tape. It doesn't matter if the tape is applied around the circumference or along the length of the dowel.

3. Wrap the cord around the dowel as desired.

4. Using the nails as handles, roll the cord wrapped dowel on a stamp pad or layer of paint rolled onto Plexiglas, completely covering the roller, and roll onto the paper.

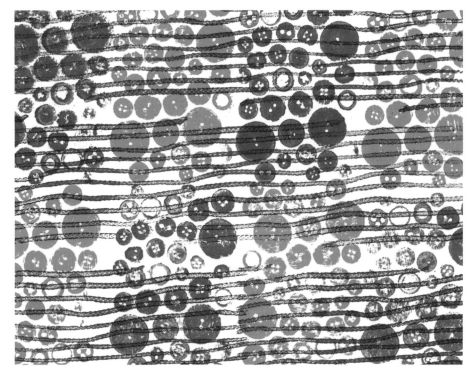

Watercolor paper was first stamped using red and orange paint with a buttons block (Lab 10), then printed using blue paint with the cord wrapped dowel.

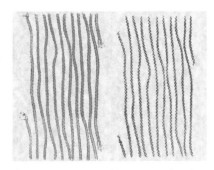

Green was printed with paint, and red was printed with a stamp pad.

Tips

- To keep the cord's ends from fraying if they are synthetic, melt them with a lit match or a cigarette lighter. Clear fingernail polish can also be applied.

- Instead of applying adhesive to the dowel, or if the ends of the cord become loose from the double-stick tape, cut a notch into each end of the dowel with a craft knife to catch and secure both ends of the cord.

- Cord can also be used to make a cord block (Lab 11).

Wire Wrapped Dowel

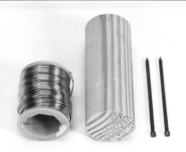

WRAPPING WIRE AROUND A DOWEL to create a printing roller is very simple, and it prints nice vertical, swaying lines, depending on how the wire is wrapped. Adhesive isn't even needed to attach the wire to the dowel. It's wrapped around one nail handle, caught in a notch made in the dowel, then wrapped to the other end and secured the same way it was started. Any weight of wire can be used to create the roller—the thinner the wire, the thinner the printed lines. If the gauge of the wire is too heavy, it can be hard to manipulate. This roller uses 20-gauge wire.

Materials

- materials for a wooden dowel roller base, 1" (2.5 cm) diameter or wider, see page 81
- craft knife or utility knife
- 20 gauge wire
- wire cutters
- paint
- brayer and Plexiglas
- paper

Printed on handmade paper using paint.

Instructions

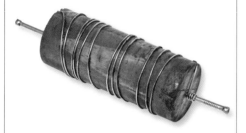

1. Make a roller base using a wooden dowel (see "How to Make a Roller Base from a Wooden Dowel," page 81).

2. Using a craft knife or utility knife, cut a notch in each end of the dowel.

3. Wrap the end of the wire around the nail at the base of the dowel, catch the wire in the notch, then wrap it around the dowel as desired to the other end. Catch the wire in the other notch, and wrap it around the nail at the base of the dowel to secure. Cut the wire close to the nail. Trim the wire at the other end if needed.

4. Using the nails as handles, roll the wire wrapped dowel on a layer of paint rolled onto Plexiglas, completely covering the roller, and roll onto the paper.

*Cardstock was first lightly covered with gesso, brayed with green paint (**Lab 29**), stamped using orange stamp pads with a flip flop (**Lab 16**), printed down the center using red paint with the wire roller, then stamped using stamp pads with a pencil eraser (**Lab 4**).*

Printed using paint.

Tips

- When wrapping the wire around the dowel, keep in mind that only the highest points will print. So although wrapping over wire isn't recommended, if you want all of the lines to print, it could result in a pleasant surprise!

- Wire can also be used to make a wire wrapped block (**Lab 13**).

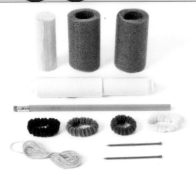

THIS LAB SHOWS ONE OF THE ALTERNATIVE USES for foam pipe insulation. Here, the insulation is wrapped with wide ponytail holders and string. When heated with an embossing heat tool, the exposed areas of the insulation melt and the areas covered with the string or ponytail holders don't. The areas that are not melted are what print. Be sure to work in a well-ventilated area. A wooden dowel can be used for the center of the roller, but if you don't want to cut any wood, a toilet paper replacement roller is the perfect diameter for insulation that fits ¾" (1.9 cm) copper pipe.

- materials for a wooden dowel roller base, 1" (2.5 cm) diameter, see page 81, or toilet paper replacement rollers

- craft knife

- cutting mat

- foam pipe insulation for ¾" (1.9 cm) copper pipe

- cotton string

- ponytail holders

- embossing heat tool

- pencil if toilet paper replacement roller is used

- stamp pad or paint

- brayer and Plexiglas if paint is used

- paper

Printed on cardstock using stamp pads, rolling one roller horizontally and the other vertically.

Printed on construction paper first using the fine-lined pipe insulation roller with a pink stamp pad, then with green paint using the foam paint trim roller (Lab 31), and then with a black stamp pad with the broad-lined pipe insulation roller.

Instructions

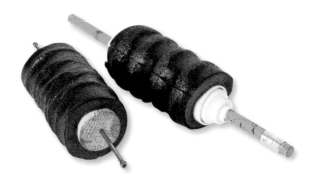

1. Make two roller bases using 1" (2.5 cm) wooden dowels (see "How to Make a Roller Base from a Wooden Dowel," page 81) or toilet paper replacement rollers.

2. Using a craft knife, cut two pieces of foam pipe insulation, approximately 3" (7.6 cm) long. Don't worry if the cut isn't straight.

3. Slip one piece onto a roller base and wrap tightly with string, securing the ends. Keep in mind that the wrapped areas will print and the exposed areas won't.

4. Slip the other piece onto a roller base and put several ponytail holders around it.

5. In a well-ventilated area, heat the foam pieces with the embossing heat tool while rotating, until the exposed areas are melted to the desired amount. It doesn't take very long to melt the foam.

How to Make a Roller Base from a Toilet Paper Replacement Roller

- Pull the ends apart and remove the spring.

- Use a craft knife to cut out any plastic material from inside both small ends, trimming the inside enough so that a pencil can later be inserted through it.

- Wrap a piece of double-stick tape around the open end of the smaller roller, insert into the larger roller, and squeeze the end with the tape so that it sticks. Or skip the double-stick tape, insert the smaller piece into the larger piece, and tape them together on the outside with masking tape.

- Put a pencil through the small holes on the ends to use as handles while printing.

6. Remove the string and ponytail holders.

7. Using the nails or pencil as the roller handles, roll the foam rollers on the stamp pad or into a layer of paint rolled onto the Plexiglas, completely covering the rollers, and roll onto the paper.

Tips

- Anything can be used as the heat resist, as long as it can hold up to being exposed to high heat.

- You can make many foam rollers to use with one core. The foam insulation easily slides on and off, whether using a wooden dowel or a toilet paper replacement roller.

Printed using a stamp pad: the print with broader lines used the roller with the ponytail holder resists; the print with the finer lines used the roller with the string resists.

Craft Foam Covered Dowel

- materials for a wooden dowel roller base, 1" (2.5 cm) diameter or wider, see page 81
- marker
- adhesive craft foam
- craft knife and/or decorative-edged scissors
- cutting mat
- measuring tape
- cork-backed steel ruler
- stamp pad or paint
- brayer and Plexiglas if paint is used
- paper

To make your own printing rollers, simply draw your design directly on the craft foam, cut it out, peel off the adhesive backing, and attach it to the roller. The design can be freeform or something that goes around the circumference of the roller and matches up. Even creating a complex, continuous design isn't difficult. The larger the circumference of the dowel, the larger the repeat of the design will be. I used a dowel with a 1¼" (3 cm) diameter, but any size can be used. This is also a great time to get out those decorative-edged scissors.

Printed on cardstock using stamp pads.

Cardstock was printed using stamp pads first with both rubber band wrapped rollers (Lab 32), then with the craft foam covered roller, then stamped with an earplug and cork (Lab 1).

Instructions

Make one roller base using a 1" (2.5 cm) wooden dowel or wider (see page 81).

To make a freeform design:

With a marker, draw shapes on the front of the adhesive craft foam, cut them out, peel off the backing, and attach to the dowel.

To make a design that meets back up with itself:

1. Measure the length and circumference of the dowel.

2. Using a craft knife and cutting against a steel ruler to get a straight top and bottom, cut a piece of craft foam to the same dimensions. (It is important to cut against a steel ruler with a craft knife instead of using scissors so that the craft foam will have a straight edge where it meets back up with itself.)

3. Using a marker, begin drawing the design starting from the top, but only draw down about one-fourth of the way.

4. On a piece of paper, mark the side edges of the craft foam. Also mark on the paper where the edges of each design element begins at the top edge of the craft foam (as if the design continued up onto the paper, but just with straight lines).

5. Move the marked paper to the bottom of the craft foam, lining up the side edges of the foam with the side marks on the paper.

6. At the bottom of the craft foam, mark the lines where the design begins.

7. Finish drawing the design on the craft foam, ending at the marked lines so the edges of each design element will begin and end at the same place.

8. Using a craft knife or scissors, cut out the design.

9. Peel off the backing and carefully attach it to the dowel, making sure that the beginning and ending of the design meet up without a gap.

For both kinds of design:

Using the nails as roller handles, roll the craft foam covered dowel on a stamp pad or layer of paint rolled onto Plexiglas, completely covering the roller, and roll onto the paper.

Printed using a stamp pad.

Tips

- Be careful when attaching the design to the dowel, especially with designs that meet up, because the craft foam can stretch. Fortunately, it's pretty malleable.

- Because the craft foam is absorbent, it will need quite a bit of stamp pad ink at first to make a solid print. But this also means you can print more before needing to recharge the roller. It doesn't absorb paint as much.

- If you don't want to cut out your own designs, you can buy all kinds of shapes of adhesive craft foam in the kid's section of craft stores.

Incised Foam Pipe Insulation

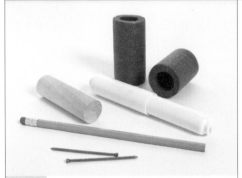

IN ADDITION TO MELTING FOAM PIPE INSULATION to use as a printing roller, as in **Lab 35**, designs can also be incised into it with a soldering iron or woodburning tool (See "Equipment," page 18).The heated tip of the tool is used to create the design by melting the foam everywhere it touches. This method of altering the pipe insulation is more controllable than melting it with an embossing heat tool. The design still needs to be somewhat simple and bold without a lot of detail because the foam melts quickly from the heat. You can either draw the design first on the foam insulation with a marker, or just improvise, making it up as you go. Be sure to do this in a well-ventilated area. The areas that are not melted are what prints. A wooden dowel can be used for the center of the roller. But if you don't want to cut any wood, a toilet paper replacement roller is the perfect diameter for insulation that fits ¾" (1.9 cm) copper pipe.

Materials

- materials for a wooden dowel roller base, 1" (2.5 cm) diameter, see page 81, or toilet paper replacement rollers

- craft knife

- cutting mat

- foam pipe insulation for ¾" (1.9 cm) copper pipe

- soldering iron or woodburning tool

- pencil if toilet paper replacement roller is used

- stamp pad or paint

- brayer and Plexiglas if paint is used

- paper

Printed on cardstock. White is paint, and black is a stamp pad.

Instructions

1. Make two roller bases using 1" (2.5 cm) wooden dowels (see page 81) or toilet paper replacement rollers (see page 95).

2. Using a craft knife, cut two pieces of foam pipe insulation to the desired lengths; the two here are approximately 3" (7.6 cm) and 2¼" (5.7 cm) long. Don't worry if the cut isn't straight.

3. Slip both pieces onto the roller bases.

4. In a well-ventilated area and using the heated soldering iron or wordburning tool, incise a design all around the circumference of the pieces by touching the tip of the tool to the foam.

5. Using the nails or pencil as the roller handles, roll the foam rollers on the stamp pad or into a layer of paint rolled onto the Plexiglas, completely covering the rollers, and roll onto the paper.

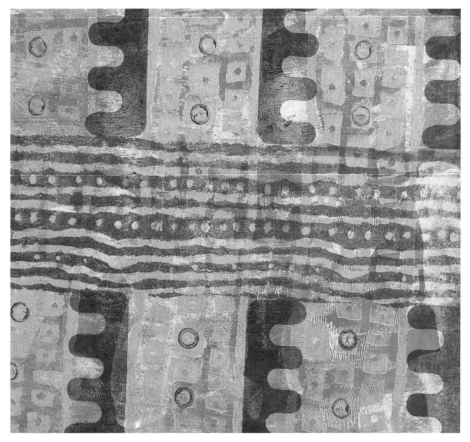

Cardstock was first lightly covered with gesso, brayed with red metallic paint (Lab 29), printed using ochre and then blue paint with both pipe rollers, stamped using a blue stamp pad with toe spacer foam (Lab 7), then stamped using blue paint with an eraser cap (Lab 4).

Printed using stamp pads.

Tip

You can make many foam rollers to use with one core. The foam insulation easily slides on and off, whether using a wooden dowel or a toilet paper replacement roller.

LAB 38 Incised Foam Marshmallow

- foam marshmallow
- hammer
- one finishing nail
- soldering iron or woodburning tool
- stamp pad or paint
- brayer and Plexiglas if paint is used
- paper

FOAM MARSHMALLOWS CAN BE FOUND IN THE KID'S SECTION of hobby and craft stores. They have many uses besides being used in kid's crafts to make snowmen and whatnot. They can also be used as moldable foam (Lab 22). Here we incise a simple design using a soldering iron or woodburning tool in one to use it as a printing roller. You can either draw the design first on the foam marshmallow with a marker or just improvise with the soldering iron or woodburning tool, making it up as you go. Be sure to do this in a well-ventilated area. The areas that are not melted are what print. This type of foam can be a little tricky to incise (or melt) with the soldering iron or woodburning tool because it doesn't melt away very easily. Therefore, start with something simple to get the hang of how it works.

Printed on cardstock using stamp pads.

Instructions

1. Mark the center of one end of the foam marshmallow. Hammer a finishing nail through this mark and out the other end, leaving enough of the nail exposed at each end to use as handles.

2. In a well-ventilated area and using the heated soldering iron or wood-burning tool, incise a design around the circumference of the foam marshmallow by touching the tip of the tool to the foam.

3. Using the nail as roller handles, roll the foam marshmallow on the stamp pad or into a layer of paint rolled onto Plexiglas, completely covering the roller, and roll onto the paper.

An old book page was printed using a pink stamp pad with a melted foam pipe insulation roller (Lab 35), stenciled using paint and a pill dispenser (Lab 42), then printed with the incised foam marshmallow, changing colors of stamp pads.

Printed using a stamp pad.

Tip

A foam marshmallow can also be used as a printing roller without incising a design on it. Using it plain will print a solid band.

Incised Brayer

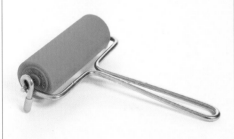

- brayer with removable soft rubber roller ("Inky Roller" by Ranger)

- soldering iron or woodburning tool

- optional: vice

- stamp pad or paint

- brayer and Plexiglas if paint is used

- paper

PRINTS FROM AN INCISED BRAYER have a monotype look, as if printed from Plexiglas that has a design painted on it. The advantage of using an incised brayer instead of a paint drawing on Plexiglas is that you get a continuous image, not just a one-off print. The brayer needs to have a removable roller, and I've had the best luck with the "Inky Roller" made by Ranger. Whether you are drawing out your design onto the roller with a marker or working improvisationally, keep in mind that the incised lines created with the soldering iron or woodburning tool will not print because they are recessed, and the untouched areas of the brayer will print. I found it easiest to make a freeform design that was somewhat horizontal, running the length of the roller. The safest method of incising is to place the roller in a vice and rotate it as needed. If you work with the roller in your hand, be mindful of your fingers and don't hit them with the heated tool!

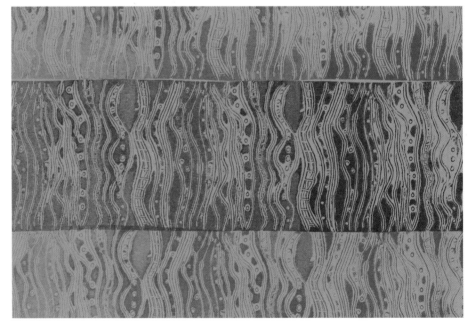

Printed with single passes on cardstock using stamp pads.

Instructions

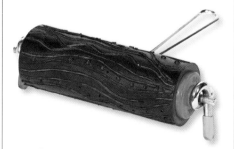

1. Remove the roller from the brayer.

2. In a well-ventilated area and using the heated soldering iron or wordburning tool, incise a design all around the circumference of the brayer roller by touching the tip of the tool to the roller. You may wish to place the roller in a vice to make this process easier.

3. Place the roller back into the brayer, roll it on the stamp pad or into a layer of paint rolled onto the Plexiglas, completely covering the roller, and roll onto the paper.

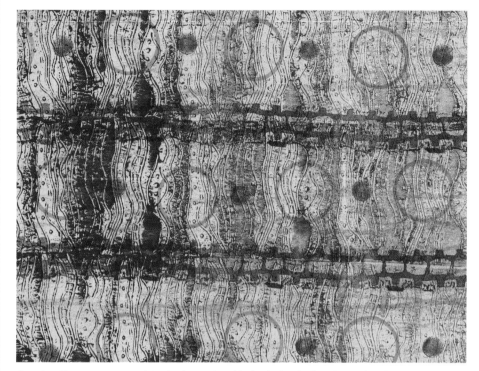

Construction paper was printed using paint with the incised roller, then printed using a black stamp pad with an incised foam marshmallow (Lab 38), then stamped using a red stamp pad with a furniture leg tip (Lab 5) and a black stamp pad with an earplug (Lab 1).

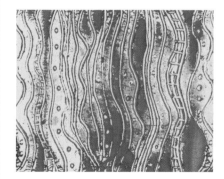

Printed using paint.

Tips

- Paint or stamp pads work equally well for printing.
- If the paint is applied too thickly onto the roller, the detail of the design will be lost and the print will be blotchy. Make sure the layer of paint on the Plexiglas is not too thick.

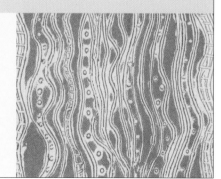

Printed using a stamp pad.

Vinyl Covered Dowel

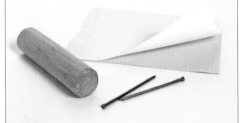

- materials for a wooden dowel roller base, 1" (2.5 cm) diameter or wider, see page 81

- marker

- adhesive-backed flexible printing plate

- optional: carving handle and blade (blades are also called cutters) The smallest V-shaped cutter (#1) is the main cutter used. (See "Equipment," page 18)

- craft knife and/or scissors

- stamp pad or paint

- brayer and Plexiglas if paint is used

- paper

THE SPECIAL MATERIAL USED IN THIS LAB is called an adhesive-backed flexible printing plate. It is vinyl, approximately ¹⁄₁₆" (16 mm) thick, and available at art supply stores (see "Resources," page 142). It is used the same way as adhesive craft foam **(Labs 14 and 36)** where a design is cut out, the backing is peeled off, and the piece is attached to a dowel. Not only can this material be cut with scissors or a craft knife, but it can also be carved! This means you can have the look of a hand-carved stamp with the continuous print of a roller. Make a simple design by drawing shapes on the vinyl, cutting them out, and attaching it to the dowel, or make it more complex by carving into the cut-out shapes. Just like the craft foam covered dowel in **Lab 36**, the design can be freeform or a pattern that goes around the circumference of the roller and matches up. The larger the circumference of the dowel, the larger the repeat of the design will be. This lab uses a dowel with a 1" (2.5 cm) diameter cut to 4" (10 cm) long, but any size can be used.

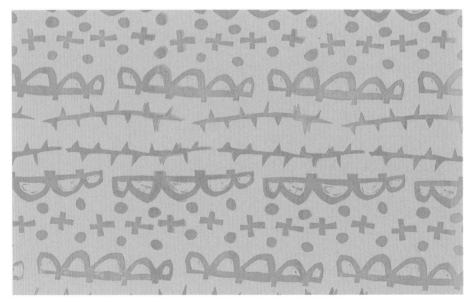

Printed on cardstock using a stamp pad, lining up the roller with the print each time the roller was recharged with ink.

Instructions

Make a roller base using a wooden dowel (see "How to Make a Roller Base from a Wooden Dowel," page 81).

To make a freeform design:

1. With a marker, draw shapes on the front of the adhesive vinyl. Carve more detail into the design using the carving tool if desired. (See **Lab 21** for more information on carving.)

2. Cut out the design, peel off the backing, and attach to the dowel.

To make a design that meets back up with itself:

1. See **Lab 36**, steps 1–9, for information on how to mark the vinyl so that the design will meet at the beginning and end.

2. Carve more detail into the design using the carving tool if desired. (See **Lab 21** for more information on carving.)

3. Using a craft knife or scissors, cut out the design.

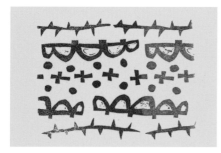

Printed using a stamp pad.

4. Peel off the backing and carefully attach the vinyl to the dowel, making sure that the beginning and ending of the design meet up without a gap.

For both kinds of design:

Using the nails as roller handles, roll the vinyl covered dowel on the stamp pad or into a layer of paint rolled onto Plexiglas, completely covering the roller, and roll onto the paper.

Watercolor paper was printed using stamp pads with the vinyl covered roller making multiple passes slightly offset to create a shadow look, and then printed using a stamp pad with an incised foam marshmallow (Lab 38).

Tip

If the paint is applied too thickly onto the roller, the detail of the design will be lost and the print will be blotchy. Make sure the layer of paint on the Plexiglas is not too thick.

Carved Brayer

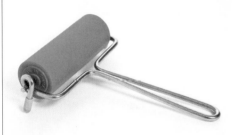

A CARVED BRAYER IS THE ULTIMATE in printing rollers. It isn't for the faint of heart because it's not easy to make, but you will be thrilled when you make your first print with it. Get at least a little experience with carving a few novelty erasers (Lab 21) before taking on this lab. Not all rollers for brayers are carvable. The two that work best are the soft rubber brayer "Inky Roller" made by Ranger, and the hard rubber brayer by Speedball. You will need to experiment to see if other kinds work for you, but the brayer needs to have a removable roller. Draw your design onto the roller with a marker before starting to carve. Depending on the design you are carving, the roller can be placed in a vice and rotated as needed or hand held. Either way, be sure to carve away from yourself and keep fingers out of the way. Carving a brayer takes much more force than carving other stamp-carving materials. Use caution!

- brayer with removable roller ("Inky Roller" by Ranger or hard rubber roller by Speedball)

- marker

- carving handle and blade (blades are also called cutters). The smallest V-shaped cutter (#1) is the main cutter used. The bigger cutters are for cutting out backgrounds. (See "Equipment," page 18)

- optional: vice

- stamp pad or paint

- brayer and Plexiglas if paint is used

- paper

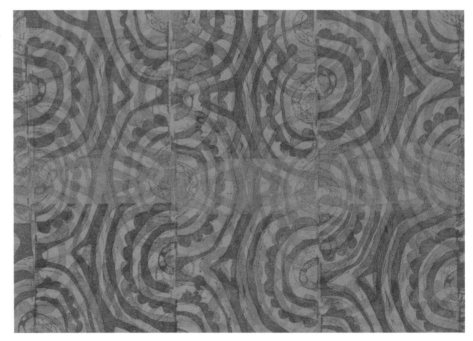

Printed using stamp pads on cardstock, making multiple passes with different colors starting at opposite ends, but always printing vertically.

Instructions

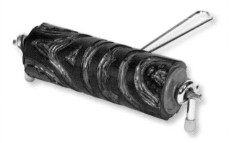

1. Remove the roller from the brayer.
2. Using a marker, draw a design onto the roller.
3. Holding the carving tool like a pencil, and carving away from yourself, carefully carve the design into the roller. (See **Lab 21** for more information on carving.) You may wish to place the roller in a vice to make this process easier.
4. Place the roller back into the brayer, roll it on the stamp pad or into a layer of paint rolled onto the Plexiglas, completely covering the roller, and roll onto the paper.

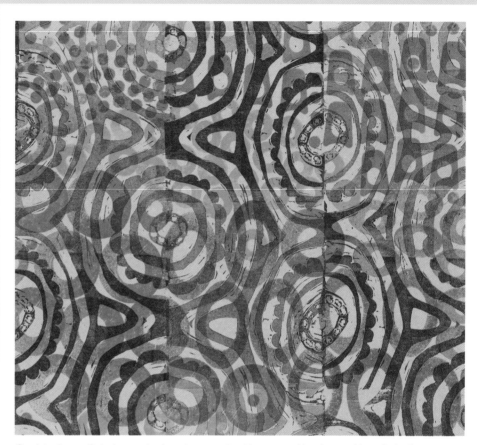

*Cardstock was first stamped using stamp pads with corn and bunion cushions (**Lab 6**), and then printed using a black stamp pad with the carved brayer starting at opposite ends, but always printing vertically. I intentionally positioned the roller so the sides of the design would match.*

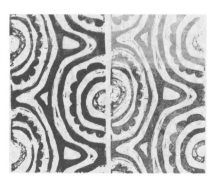

Red was printed with paint, and green was printed with a stamp pad.

Tip

If the paint is applied too thickly onto the roller, the detail of the design will be lost and the print will be blotchy. Make sure the layer of paint on the Plexiglas is not too thick.

Stencils

PRINTING WITH STENCILS IS DIFFERENT from printing with stamp tools, blocks, and rollers. With a stencil, paint or ink is forced down through the tool instead of using the tool to apply the paint or ink.

Here we scavenge and use everything from drain strainers, birth control pill dispensers, scrapbooking die cut paper, and felt place mats to stencils cut from sheet protectors. Your imagination is the only limit here. As long as an item is flat, can temporarily hold up to having paint or stamp pads on it, and has some areas cut out of it, it will work as a stencil.

There are three main items needed for most of the labs in this unit: the stencil itself; a stiff, round brush; and paint. Fat paintbrushes found in the kid's section of craft and hobby stores are great because they are inexpensive and come with several to a package. If the bristles are too long, making them not very stiff, give them a haircut with a pair of scissors to make them shorter. Stenciling works better with a brush that is almost dry. Using too much paint on the brush will

UNIT 4

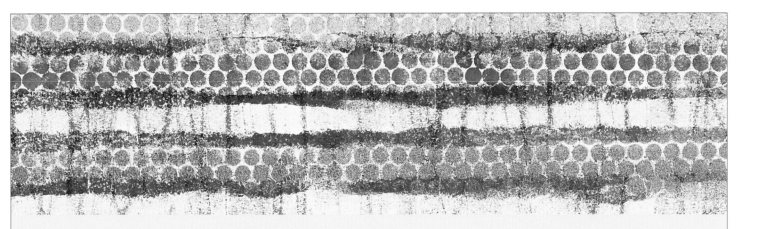

not give a crisp effect, and wet paintbrushes don't work as well. Keep several dry brushes ready to go in case you want to change colors. Often, when I change colors, I don't bother cleaning the brush or getting a clean, dry one—I just switch to the new color of paint. That creates a nice transition from one color to the next. Be sure to let the paint dry before working over a stenciled area again. Otherwise, you will transfer wet paint onto the back of the stencil, and then transfer that somewhere on the paper where you don't want it.

Whether thick or thin paints work best depends on the thickness of the stencil. With thin stencils, like the paper doilies (Lab 44), you can use any kind of paint, while thicker stencils, like the kitchen sink mat (Lab 47), need thick paint. Thin paint tends to bleed under the thicker plastic stencils, but if it's absorbent, like the die cut felt, any kind of paint will work.

I normally use a brush and paint for stenciling, but several of the labs using thin stencils, such as the hand-cut stencils in Labs 51 and 52, will work great using a sponge to apply the paint over the stencil, or a small raised stamp pad used in the same way. You'll need to experiment to see which materials work best for the stencil you are using.

Be sure to read the "Basics" chapter starting on page 10. This has important information on acrylic paints, stamp pads, printing, and equipment.

Tips

- With thin stencils, mini stamp pads with a raised pad can be used for stenciling. Use the pad the same as you would a stencil brush.

- Dab around the outer edges of a stencil for a spray-painted effect.

LAB 42 Pill Dispenser

THESE BIRTH CONTROL PILL DISPENSERS print nice rows of little circles stacked on top of each other. The dispenser style depends on the brand of pills. If you don't have your own, ask your friends. They couldn't be easier to use for stencils. Take out the removable foil blister pack that housed the pills, break off or cut off the folding top, and you're good to go!

Materials

- paint
- Plexiglas
- stencil brush or stiff, round paintbrush
- pill dispenser
- paper

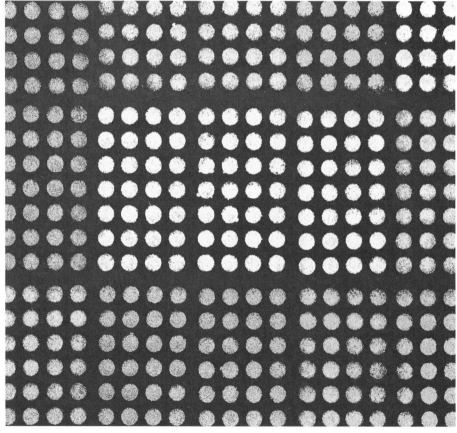

Stenciled on cardstock with different colors of metallic paint.

Instructions

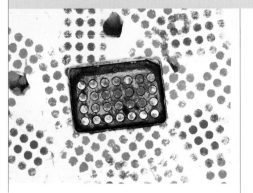

1. Put some paint on a piece of Plexiglas.

2. Dab the paintbrush in the paint. Tap the tip of the brush on the Plexiglas to remove any excess paint.

3. Place the flat side of the pill dispenser stencil on the paper.

4. Holding the edges of the dispenser with one hand and the brush straight up with the other hand, tap the brush on top of the dispenser to push the paint through the open areas.

5. Move the brush around, adding more paint to it as needed, until the desired area is stenciled.

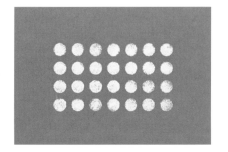

Stenciled using metallic paint.

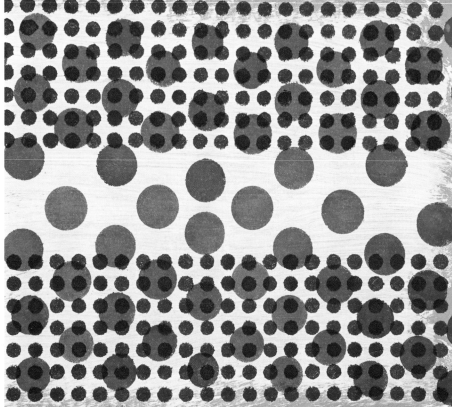

Cardstock was first lightly covered with gesso, and then stenciled using red paint with a plastic basket (Lab 48), then blue paint with the pill dispenser.

Tip

To get an evenly spaced, allover pattern with the pill dispenser, line up the last row or column of printed circles on the paper with the first row or column of holes in the pill dispenser. Don't stencil back over the first row or column that is already printed.

Sequin Waste

Materials

- paint
- Plexiglas
- stencil brush or stiff, round paintbrush
- sequin waste
- paper

SEQUIN WASTE IS THE REMAINS from strips of metallic material that sequins are punched from. You can find it in fabric stores in the trims section or in craft stores in the floral section. It comes on spools, and sometimes you have to buy the whole spool, but some fabric stores sell it by the foot. Check around the holidays in the crafts stores because it is also used on wreaths. Regardless of when or where you find it, it's inexpensive, so you can get enough to share with your friends. Cut off about a 6" (15 cm) piece to use because anything longer is hard to handle. Unlike the pill dispenser stencil (Lab 42), these holes form a honeycomb pattern rather than holes that are lined up in rows and columns. Because it's so inexpensive and durable, I don't bother cleaning it and just let the paint dry on it.

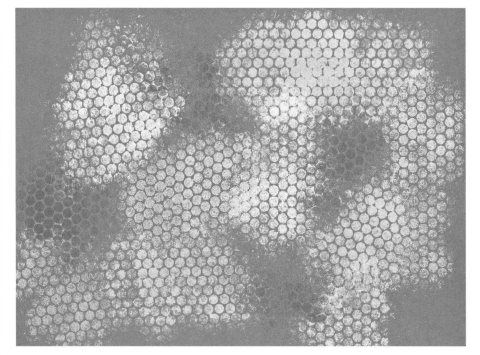

Randomly stenciled on cardstock with different colors of metallic paint.

Instructions

1. Put some paint on a piece of Plexiglas.

2. Dab the paintbrush in the paint. Tap the tip of the brush on the Plexiglas to remove any excess paint.

3. Place the sequin waste on the paper.

4. Holding the edges of the sequin waste with one hand and the brush straight up with the other hand, tap the brush on top of the stencil to push the paint through the open areas.

5. Move the brush around, adding more paint to it as needed, until the desired area is stenciled.

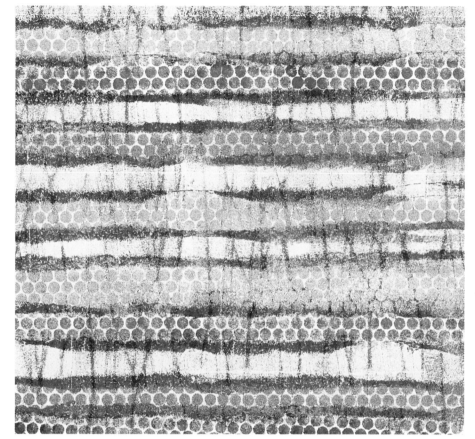

Cardstock was first printed using blue and red stamp pads with both foam pipe insulation rollers (Lab 35), rolling one horizontally and the other vertically, then stenciled between the wide blue roller lines using metallic paints with the sequin waste.

Stenciled using paint.

Tip

The bottom row of holes in the sequin waste can be lined up with the top row of printed circles on the paper to create a bigger allover pattern, but I find it more interesting to stencil randomly.

LAB 44 Paper Doilies

- paint
- Plexiglas
- stencil brush or stiff, round paintbrush
- paper doilies
- paper

PAPER DOILIES ARE EASY AND INEXPENSIVE items to use as stencils, and there are usually quite a few in a package. They can come in all different shapes, sizes, and patterns. They are normally used under cakes, other baked goods, and candies to make a nice presentation. You can find them in the cake decorating or wedding decoration aisles of craft stores. Around the time of seasonal celebrations that use decorations, such as Valentine's Day and St. Patrick's Day, you can often find doilies that are heart or shamrock shaped, such as those used here. Even though paper doilies are made out of paper and are usually quite thin, they are fairly durable and can be used quite a few times. The metallic ones are thicker and hold up better than the paper ones.

Randomly stenciled on cardstock with different colors of paint.

Instructions

1. Put some paint on a piece of Plexiglas.

2. Dab the paintbrush in the paint. Tap the tip of the brush on the Plexiglas to remove any excess paint.

3. Place the doily stencil on the paper.

4. Holding the edges of the doily with one hand and the brush straight up with the other hand, tap the brush on top of the doily to push the paint through the open areas.

5. Move the brush around, adding more paint to it as needed, until the desired area is stenciled.

An old book page was first brayed with ochre and red paint (Lab 29), stenciled with the doilies, and then stamped using paint with an eraser cap (Lab 4).

Stenciled using metallic paint.

Tip

When the paper doilies won't hold up anymore to use as stencils, they make great colorful and textured collage material.

Alphabet Stencils

- paint
- Plexiglas
- stencil brush or stiff, round paintbrush
- alphabet stencils
- paper

ALPHABET STENCILS CAN BE FOUND IN TWO FORMS. One is a piece of thick plastic with all of the letters on it, and the other is a long strip of perforated squares with one letter per square, made out of oil board. Both kinds come in many different sizes of letters. The plastic type is usually called a lettering guide or lettering template and comes with several sizes in one package. The oil board is a thick paper impregnated with drying oils. That means it's durable and reusable, and paint won't hurt it. It also comes in many different sizes, but only one size per package. Typically, the letters are separated so that you can easily spell words when stenciling. I like using it with several letters still attached in strips. Normally, when I use the alphabet stencils, I'm not trying to spell out anything, I just use them as a design or to create a visual texture. Both kinds of stencils can be found in craft stores in the section for making signs, or in the drafting or art supply section. Some hardware stores carry the oil board stencils. Both kinds are usually inexpensive.

Many layers randomly stenciled on cardstock using different colors of paint with all of the alphabet stencils.

Instructions

1. Put some paint on a piece of Plexiglas.

2. Dab the paintbrush in the paint. Tap the tip of the brush on the Plexiglas to remove any excess paint.

3. Place the alphabet stencil on the paper.

4. Holding the edges of the stencil with one hand and the brush straight up with the other hand, tap the brush on top of the stencil to push the paint through the open areas.

5. Move the brush around, adding more paint to it as needed, until the desired area is stenciled.

Stenciled using paint.

Cardstock was first lightly brayed with blue paint (Lab 29), stenciled using blue and black paint with the alphabet stencils, then stamped using a white stamp pad with a craft foam block of stars (Lab 14).

Tip

Use the alphabet stencil from the wrong side with the letters backward, to make them more abstract.

IT'S EASY TO FIND ITEMS that are made specifically for stenciling. But it's more fun to find things that are intended for another use but will work just as well. One of those items is die cut paper made for scrapbooking. The die cut paper I've found is heavy enough to work as a stencil. Some of the papers are quite ornate and create a wonderful image. You can find these specialty papers in the scrapbooking section of craft stores. They can be purchased in packages with several different designs or as individual sheets.

Materials

- paint
- Plexiglas
- stencil brush or stiff, round paintbrush
- scrapbooking die cut paper
- paper

Cardstock was stenciled on the top and bottom using red paint with the flower and butterfly die cut paper, working past the edge of the stencil to make the scalloped band, then the middle was stenciled using blue paint with the spiral die cut paper.

Instructions

1. Put some paint on a piece of Plexiglas.

2. Dab the paintbrush in the paint. Tap the tip of the brush on the Plexiglas to remove any excess paint.

3. Place the die cut paper on the paper to be printed.

4. Holding down the area of the die cut paper where you'll be stenciling with one hand and the brush straight up with the other hand, tap the brush on top of the stencil to push the paint through the open areas.

5. Move the brush around, adding more paint to it as needed, until the desired area is stenciled.

Cardstock was first stenciled with the spiral die cut paper around the edges using blue and metallic green paint, and then using blue paint in the center with the flower and butterfly die cut paper. It was then stamped using red paint with a foam marshmallow molded with a spiral wire (Lab 22) and a metallic copper stamp pad with a pencil eraser (Lab 4).

Stenciled using paint.

Tip

If you stencil with the die cut paper a lot in one session, you might need to dry it with a hair dryer while you're working. If it gets too wet from paint, it might become fragile.

Kitchen Sink Mat

LOTS OF FOUND OBJECTS can be used for stenciling circles, but squares are a little harder to come by. This kitchen sink mat from my dollar store was great for stenciling squares. By nature it's washable and durable! Because it's so flexible, it can either be stored flat or rolled up. If the size is too cumbersome, cut it into smaller pieces with a craft knife.

Materials

- paint
- Plexiglas
- stencil brush or stiff, round paintbrush
- kitchen sink mat
- paper

Stenciled on cardstock alternating columns of blue and green paint.

Instructions

1. Put some paint on a piece of Plexiglas.

2. Dab the paintbrush in the paint. Tap the tip of the brush on the Plexiglas to remove any excess paint.

3. Place the sink mat on the paper.

4. Holding down the area of the sink mat where you'll be stenciling with one hand and the brush straight up with the other hand, tap the brush on top of the stencil to push the paint through the open areas.

5. Move the brush around, adding more paint to it as needed, until the desired area is stenciled.

An old book page was first brayed with coral paint (Lab 29), stenciled using blue paint with the sink mat, then stamped using blue and red stamp pads with corks (Lab 1), gold paint with an earplug (Lab 1), and an orange stamp pad with a furniture leg cup (Lab 5).

Stenciled using paint.

Tips

- If the sink mat won't lie flat after storing it rolled up, soften it up with hot water or a hair dryer and flatten it.

- To stencil a larger area than the sink mat, line up the last row or column of printed squares on the paper with the first row or column of square holes in the sink mat. Don't stencil back over the first row or column that is already printed.

48 Plastic Basket

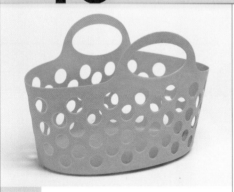

WHEN LOOKING FOR ITEMS TO REPURPOSE into printing tools, you have to be open to everything. That's how I found this inexpensive basket at the dollar store. It has all of the qualities you look for in a repurposed stencil: it's durable and washable, can easily be cut with scissors or a craft knife, is interesting, and is cheap! I love that the circles vary in size and that they form a soft arc. I cut off one side of the flexible basket with a pair of scissors and left the handle in case I ever wanted to stencil a really big oval.

Materials

- scissors or craft knife and cutting mat
- plastic basket
- paint
- Plexiglas
- stencil brush or stiff, round paintbrush
- paper

Cardstock was first stenciled horizontally covering the bottom half of the paper with the basket handle facing up, then rotated 180 degrees and the other half was stenciled. The brush wasn't cleaned when changing between orange, green, and ochre paints to create the subtle color changes.

Instructions

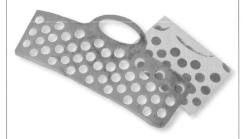

1. Using scissors or a craft knife, cut off a piece of the basket to be used as a stencil, making sure that it will lie flat.

2. Put some paint on a piece of Plexiglas.

3. Dab the paintbrush in the paint. Tap the tip of the brush on the Plexiglas to remove any excess paint.

4. Place the basket piece on the paper.

5. Holding down the area of the basket where you'll be stenciling with one hand and the brush straight up with the other hand, tap the brush on top of the stencil to push the paint through the open areas.

6. Move the brush around, adding more paint to it as needed, until the desired area is stenciled.

Cardstock was first printed using blue and green stamp pads rolling both rubber band wrapped rollers (Lab 32) vertically, then stenciled horizontally with the basket over the bottom half of the paper using ochre paint with the basket handle facing down; then it was rotated 180 degrees and the other half was stenciled. Then using stamp pads, green was stamped with an earplug (Lab 1), orange and metallic blue with a pencil eraser (Lab 4), and red with a pencil grip (Lab 3).

Stenciled using paint.

Tip

Because the holes in the basket change in size from the top to the bottom and are in a soft arc, depth and optical illusions can be created by printing the basket on half of the paper, then flipping it and stenciling the other half. Experiment with placement and color to get the desired effect.

Drain Strainer

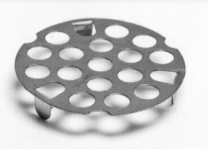

- paint
- Plexiglas
- stencil brush or stiff, round paintbrush
- drain strainer
- paper

WHILE CRUISING MY HARDWARE STORE looking for fun things to play with, I came across a drain strainer. Eureka! Not only would it make a great stenciling tool because it had little holes cut into it, but it was also a circle. That meant the resulting stenciled print would be a large circle with smaller circles inside. At first I thought I'd have to clip off or fold the three little prongs that helped hold it in the drain, but I discovered those prongs made excellent little handles for picking it up after the piece was stenciled. They come in different sizes for your stenciling (and drain straining) pleasure.

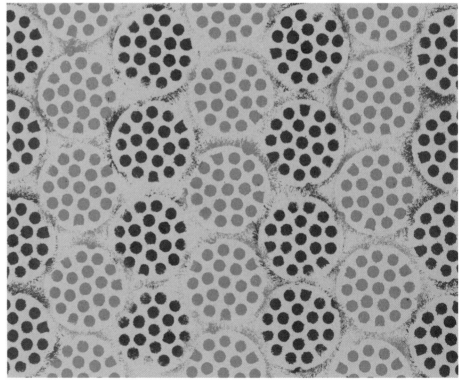

Stenciled using paint on cardstock in a honeycomb pattern, alternating rows of color.

Instructions

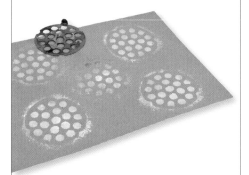

1. Put some paint on a piece of Plexiglas.

2. Dab the paintbrush in the paint. Tap the tip of the brush on the Plexiglas to remove any excess paint.

3. Place the drain strainer with the flat side down on the paper.

4. Holding down the edges of the strainer with one hand and the brush straight up with the other hand, tap the brush on top of the stencil to push the paint through the open areas.

5. Move the brush around, and carefully move your fingers so you can stencil the entire piece, adding more paint to the brush as needed.

Cardstock was first printed using black and white stamp pads with both incised foam pipe insulation rollers (Lab 37), then stenciled using orange paint with the drain strainer.

Stenciled using metallic paint.

Tip

Don't worry if the paint slightly bleeds under the drain strainer while you are stenciling, giving the holes a feathered look. It adds to the spray-paint grunge look, giving it some character.

LAB 50 Die Cut Felt

BECAUSE PART OF MY REPURPOSING PLEASURE involves finding several uses for an item, I was giddy when I first found these die cut felt items in craft and dollar stores. I knew that I could use them both for printing and for stenciling. The large felt piece used here was meant to serve as a festive place mat, and the smaller piece, a coaster. I've turned them into dual-purpose printing tools. Check out **Lab 18** to see how you can print with them. Here, learn how you use them as stencils. As with most things, you can find specialty designs around holidays, such as heart or star die cut felt ornaments.

Materials

- paint
- Plexiglas
- stencil brush or stiff, round paintbrush
- die cut felt place mat and coaster
- paper

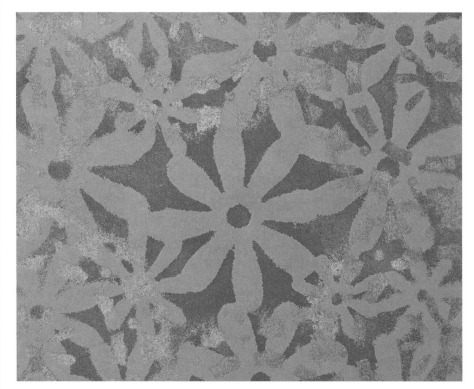

Cardstock was first stenciled using red metallic paint with the place mat, then using green metallic paint with the coaster.

Instructions

1. Put some paint on a piece of Plexiglas.

2. Dab the paintbrush in the paint. Tap the tip of the brush on the Plexiglas to remove any excess paint.

3. Place the die cut felt down on the paper.

4. Holding down the area of the felt where you'll be stenciling with one hand and the brush straight up with the other hand, tap the brush on top of the stencil to push the paint through the open areas.

5. Move the brush around, adding more paint to the brush as needed, until the desired area is stenciled.

Construction paper was first printed using a green stamp pad with the carved brayer (Lab 41), then stenciled using red paint with the place mat and blue paint with the coaster .

Stenciled using paint.

Tips

- To evenly stencil a larger area with the place mat, move it around to match up some of the flowers and keep some continuity with the design.
- You don't need to wash these when you're done stenciling. Just let the paint dry on them.

AS MUCH FUN AS IT IS TO REPURPOSE THINGS for stencils, it's also quite satisfying to actually create your own. They can be simple or ornate, but keep in mind that they need to be made as one piece. While planning the design, remember that it will be cut out with a craft knife rather than scissors. Any kind of thin plastic, such as these sheet protectors, can be used as the material for the stencil. They are easy to cut with a craft knife, inexpensive, and readily available.

Materials

- sheet protector
- craft knife with a sharp blade
- permanent marker
- cutting mat
- paint
- Plexiglas
- stencil brush or stiff, round paintbrush
- paper

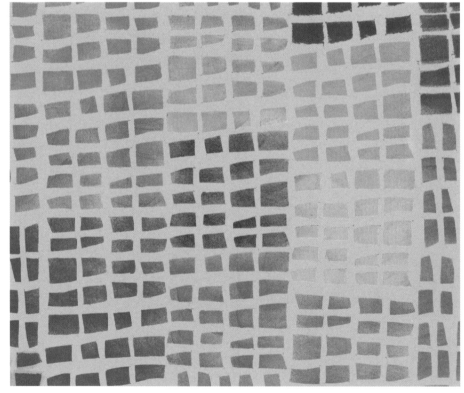

Stenciled using stamp pads on cardstock.

Instructions

1. Cut the sides and bottom of the sheet protector so there is only one layer of plastic to work with.

2. Using the permanent marker, draw a design on the sheet protector.

3. Place the sheet protector on top of the cutting mat, and cut it to a smaller size, leaving a margin around the design. Carefully cut out the design with a craft knife.

4. Put some paint on a piece of Plexiglas.

5. Dab the paintbrush in the paint. Tap the tip of the brush on the Plexiglas to remove any excess paint.

6. Place the sheet protector stencil down on the paper.

7. Holding down the stencil with one hand and the brush straight up with the other hand, tap the brush on top of the stencil to push the paint through the open areas.

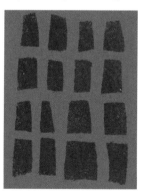

8. Move the brush around, adding more paint to the brush as needed, until the desired area is stenciled.

Stenciled using paint.

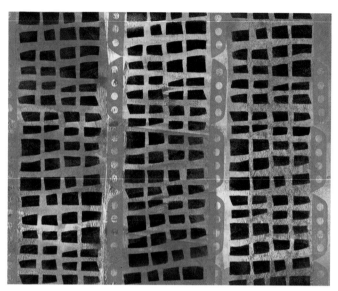

Cardstock was first brayed with white paint (Lab 29), stenciled using black paint with the sheet protector stencil, then stamped using a gold stamp pad with the foam bit caddy (Lab 8).

Tips

- If you make a mistake while cutting out the design, fix it with clear tape. Put a piece on both sides of the mistake, and recut what is needed.

- If you have trouble stenciling crisp edges with paint and a brush, try using a stamp pad. Mini stamp pads with a raised pad can be used for stenciling. Dab it on just as you would a stencil brush. A small sponge can also be used to stencil the paint onto the paper.

- Sheet protector stencils can be somewhat fragile depending on the design that is cut from them. Whether cleaning with water or a baby wipe, be careful not to tear the plastic.

Stencil Film

- permanent marker
- stencil film
- scissors
- piece of glass (that is at least bigger than your design)
- soldering iron or woodburning tool
- paint
- Plexiglas
- stencil brush or stiff, round paintbrush
- paper

IN SEVERAL OF THE LABS FROM UNIT 3, a soldering iron or woodburning tool is used to incise designs in different materials to make printing rollers. In this lab, heat is used to cut a stencil out of stencil film. The heated tip melts through the plastic, cutting out the design. Stencil film is durable and won't tear. Other plastics can be used, including plastic container lids, but they are a little trickier to work with. After getting the hang of using a woodburning tool to cut out stencils, experiment with other handy plastics. Some plastics create more of a ragged edge when melted, but this could be used as a design element. Stencil film can be found in various departments in craft and art stores, and even in fabric stores. It is important to use a piece of glass under the film while cutting it with the woodburning tool. Anything else will melt or be damaged from the heat.

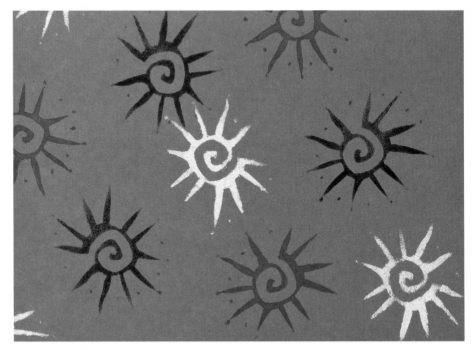

Stenciled using stamp pads on cardstock.

Instructions

1. Using the permanent marker, draw a design on the stencil film.

2. With scissors, cut the film to a smaller size, leaving a margin around the design.

3. Place the stencil film on top of the glass, and carefully cut out the design with a heated soldering iron or woodburning tool. Do this by touching the heated tip of the tool to the stencil and moving it as if you were drawing.

4. Put some paint on a piece of Plexiglas.

5. Dab the paintbrush in the paint. Tap the tip of the brush on the Plexiglas to remove any excess paint.

6. Place the stencil down on the paper.

7. Holding down the stencil with one hand and the brush straight up with the other hand, tap the brush on top of the stencil to push the paint through the open areas.

8. Move the brush around, adding more paint to the brush as needed, until the desired area is stenciled.

Stenciled using paint.

Stenciled using a stamp pad.

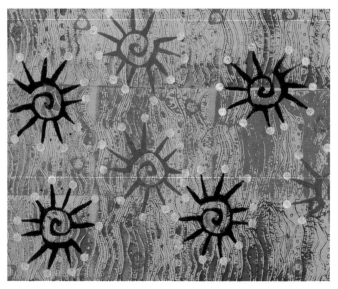

Cardstock was first printed using paint with an incised brayer (Lab 39), and then stenciled using stamp pads, and then stamped using gold paint with a pencil eraser (Lab 4) and blue paint with a pencil grip (Lab 3).

Tips

- If you have trouble stenciling crisp edges with paint and a brush, try using a stamp pad. Mini stamp pads with a raised pad can be used for stenciling. Use the pad the same as you would a stencil brush.

- A small sponge can also be used to stencil the paint onto the paper.

- Experiment with the soldering iron or woodburning tool to see how fast or slow to "draw" with the tool, or which direction works better for you, drawing away from or toward yourself.

- For an inexpensive piece of glass, buy a picture frame with glass in it.

Gallery

HERE ARE SOME IDEAS for ways to apply what you've learned in the different labs. The purpose here is to inspire you to be creative and use your printing and stamping tools on a wide variety of items to spice them up. Don't feel that you need to go buy brand new things to print on. Many of these items were already around my house or picked up very inexpensively at thrift or dollar stores. Using inexpensive items takes the pressure off of messing up and gives you the freedom to experiment.

Be sure to use the ink, acrylic paint, or fabric paint that is appropriate for your surface. If the item will get a lot of use but isn't fabric, spraying a light coat of a workable fixative or sealer on it will help protect the work. Use fabric paint or ink, following the directions on the label, on fabric or clothing that will be laundered.

Test to see if a stamp pad or paint would work best on the piece in an area that won't show or that will be covered by something else. Unless you're using a permanent stamp pad that dries instantly, you can usually wipe paint or stamp pad ink right off a slick surface, such as faux leather shoes or purses. This can come in handy if you make a mistake. But don't worry! If you do mess up, there is always a creative solution! For further instructions to make these projects, visit: www.TraciBunkers.com

Stationery

Printing your own stationery is simple. You can either make your own envelopes or buy them along with matching paper in craft and art supply stores. When printing on the envelopes, insert a thick piece of paper or cardboard inside to keep the ink or paint from bleeding through to the other side. Don't print thick paint in the area where you will be writing; it will be hard to write on.

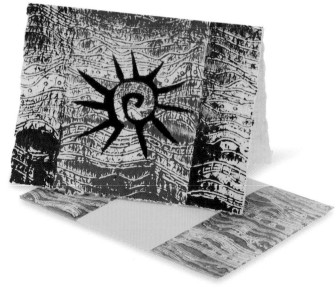

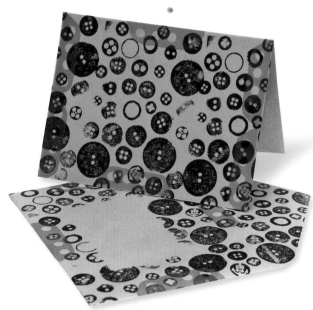

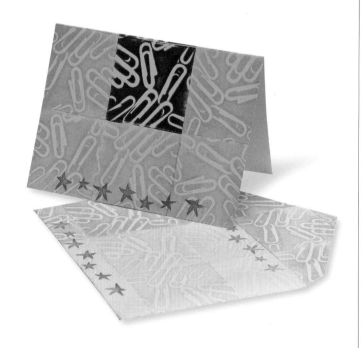

Candleholders

Glass candleholders can be carefully stamped with permanent stamp pads, and the transparent quality of the design gives a stained glass look. Flat surfaces are easier to stamp, but round holders can be stamped with smaller stamps. These are sprayed with a workable fixative after stamping to help protect them. If you have trouble stamping on the glass because it is slick, spraying a thin layer of workable fixative on the surface will help. But the slickness can also work to your advantage. If you make a mistake, you can wipe it off quickly before it dries.

Books

Sketchbook, journal, and scrapbook covers are perfect to print on because of the firm, flat surfaces. Plus, a personalized book may inspire you to work in it. Non-slick surfaces are the easiest to print on, but slick or glossy covers can be collaged or lightly sanded first to create a little tooth, which gives the paint something to hold on to.

Picture Frames

Remove the glass from picture frames to protect it while you are printing. When choosing colors or tools to print on a frame, think of the picture that will be in the frame. These frames hold my own photographs.

Shoes

Depending on the shoe and the printing tool, it might help to firmly stuff the shoe with paper to create a sturdier printing surface. Sometimes putting your hand inside and directly under the area you are printing is all you need. The white canvas shoes show the work in progress.

Laptop Sleeves and Bag

Laptop sleeves and bags are wonderful, blank printing surfaces. They come in various materials that can be printed on. Depending on the bag and tool, it might be easier to firmly stuff the inside or insert a piece of thick cardboard to create a sturdier printing surface. Sometimes putting your hand inside and directly under the area you are printing on is all you need. Or adjust the shape of the item, making a flatter surface to make printing easier.

Purses

Purses are fun to print on, easy to find at local thrift stores, and great for trying out your new printing skills and tools. Stuff the insides with paper to make it easier to print on or simply put your hand inside directly under the area where you are printing.

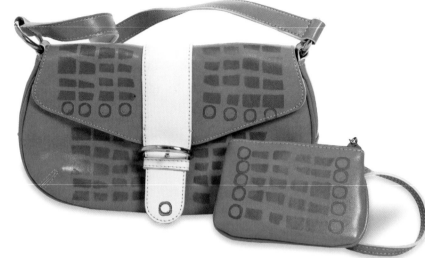

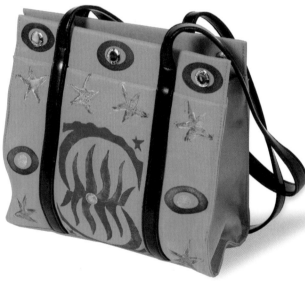

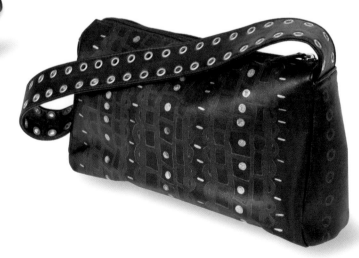

Tote Bags

Tote bags can be used for everything, so it's fun to print interesting designs on them. You can either dress up a boring tote bag, printing over what came printed on it, or start with a blank one. Put a piece of cardboard or stack of newspapers inside to make a better printing surface and also to keep the paint or stamp pads from bleeding through to the other side. Although fabric paints can be used, these feature acrylic paints and permanent stamp pads. The bags are still washable because acrylic paint just doesn't come off!

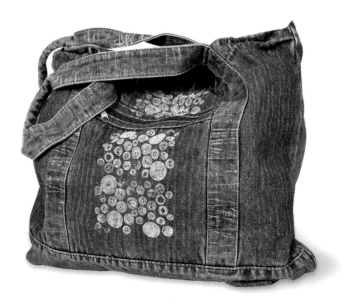

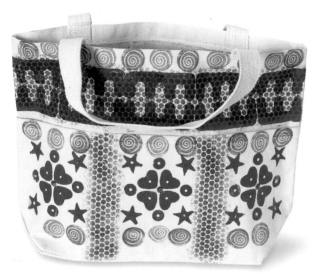

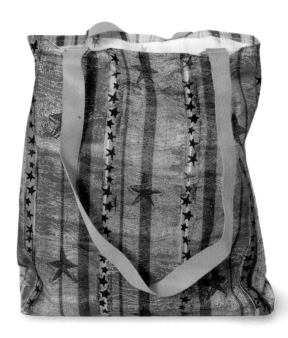

Visual Journal Pages

I'm an avid visual journalist, and I use my printing tools in my journal on a regular basis. I like to work on printed pages from old books, and these pages were lightly covered with gesso to subdue the original printing.

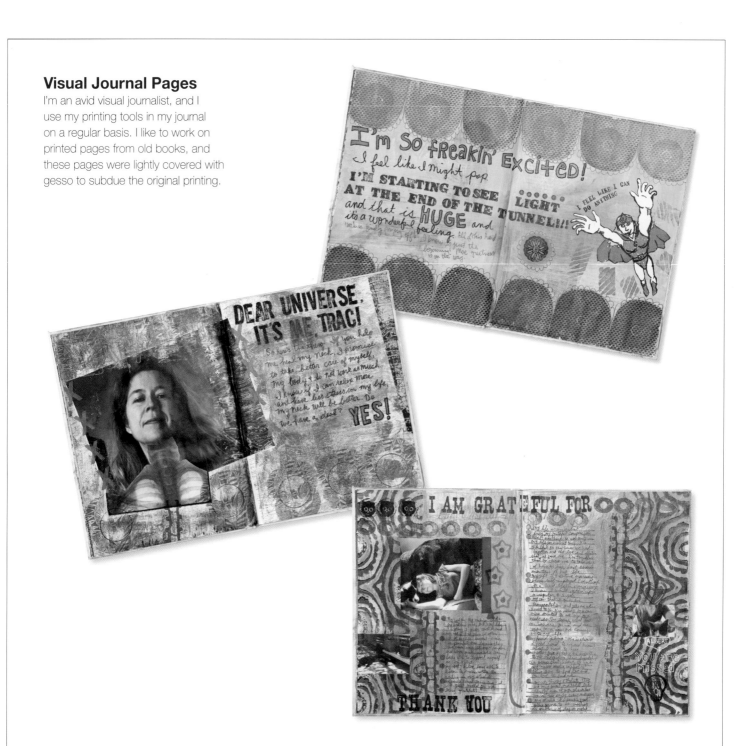

Resources

MANY OF THE MATERIALS USED IN THIS BOOK that you don't already have can be found locally in hobby stores, craft stores, art supply stores, hardware store, thrift stores, or discount dollar stores. Here is a list of some sources for mail order. Also, please visit my website for more inspirational links and to see more of my artwork incorporating these techniques and others.

Traci Bunkers/Bonkers Handmade Originals
workshops, rubber stamp and mixed-media supplies, rubber texture sheets for moldable foam, do-it-yourself kits
www.TraciBunkers.com
P. O. Box 442099
Lawrence, KS 66044

Daniel Smith, Inc.
papers and art supplies
www.danielsmith.com

Dick Blick Art Materials
art and craft supplies
www.dickblick.com

Golden Artist Colors
acrylic paints, mediums
www.goldenpaints.com

Jerry's Artarama
art and craft supplies
www.jerrysartarama.com

MisterArt
art and craft supplies
www.misterart.com

Tsukineko
rubber stamp pads
www.tsukineko.com

Utrecht Art Supplies
art supplies
www.utrechtart.com

About the Author

Traci Bunkers is a passionate and quirky self-employed mixed-media and fiber artist living in Lawrence, Kansas. "I love rusty things, glitter glue, old books to cut up, and cheap cameras. I'm smiling when my hands are dirty with paint or when I've altered a camera or something to use as a printing tool. It means I'm doing what I love—making art and doing things with my hands. Lucky for me, I do what I love for a living." Even though the DIY and repurposing lifestyles are now in vogue, for this self-proclaimed love child of MacGyver, reusing and repurposing have always been her way of life as a creative way to problem solve and make ends meet. Through her one-woman business Bonkers Handmade Originals, she sells her nifty creations such as hand-dyed spinning fibers and yarns, original rubber stamps, handmade books, kits and original artwork. She also creates an artzine called *Tub Legs*, designs knitwear, and is a knitting, spinning, and crochet technical editor. She has been teaching workshops across the United States since the early '90s and her visual journal pages, artwork, and knit designs have been published in numerous books and magazines. To learn more about her work, visit her website at www.TraciBunkers.com.

Acknowledgments

I want to wholeheartedly thank my friend and agent, Neil Salkind, for his unending support and belief in me. Without him, none of this would be possible. Many thanks go to my friend, Lydia Ash, for feeding me while I was writing the book. She had the great idea to barter her gourmet meals for my rubber stamps and supplies so that I wouldn't have to worry about cooking while working on my book. Much love and thanks to my soul sister, Juliana Coles, for always being there and just because. To my pets and especially my dog, Ruby, for their patience with my never-ending work schedule that cut into their undivided attention time. Thanks to my mom, Pennie Bunkers, for taking care of Ruby during my teaching travels which helped me develop the concept for this book. And thanks to all of my workshop organizers, students, and followers over the years. Last but not least, a huge thanks to my editor, Mary Ann Hall, and the whole crew at Quarry Books for publishing my book and for turning it into a tasty treat. This is dedicated to all of you.

Special thanks to Golden Artists Colors and Tsukineko for generously supplying some of the paints and stamp pads I used in creating this book.